Sue Anne Bottomley

9-19

Pep Talks for the Would-Be, Should-Be Artist

Sue Anne Bottomley

Book design by Karin Tracy

ISBN: 978-1-944393-20-5

Acknowledgements

My thanks go to many people who have encouraged my art life. Starting with my family—my parents, grandparents, aunts, and uncles, who all had a strong interest in the arts. Some of them were artists. And in current times, my siblings, children, grandchildren, and spouse. Some of them are artists too. We are an art loving family. We appreciate and talk about good design and architecture. Then came my teachers, both in high school and in college. The art professors at the University of New Hampshire were very caring people, and I remember them and their lessons fondly.

I appreciate Tom Holbrook at Piscataqua Press for believing in me and my art. I love my husband with his eye for detail and his fine techie brain. And our older daughter Karin, who designed the layout of the book in her precious spare time. Thank you.

As a way of being very grateful for those who have encouraged me along the way, I aim to give courage, hope, and direction to others who have the urge and desire to take pen to paper. To record their world, find themselves, and show others the possibilities.

March 2016

Dedication

The international community of people who love to draw their little corner of the world is growing rapidly. When these sketches are posted online, it is perfect armchair traveling. I dedicate this book to them.

Introduction

When I am sketching, most people don't even notice me. This is OK because I am not on display as an 'artiste'. I am focusing intently on the chosen subject—architecture, a street scene, or a landscape. And sometimes a total stranger who becomes a part of the composition. Other times, a family member or a group in a familiar setting will attract my attention. I have a sense that a moment is fleeting and it is important to capture.

Sometimes, however, people will approach me for a short conversation. To offer me a quick compliment or tell me that their aunt paints. Or they admit that they once sketched too, but have stopped. Perhaps they felt that their drawings were not good enough. Or they really have the desire and urge to start again, but can't seem to do it. Their frustration is palpable to me, and I would like to help.

The pages of pep talks are meant to inspire and reaffirm a person's desire to make art. The second aspect of the book is a collection of drawings that I have done over the years in many locations, many different countries even. I chose these particular drawings, as each had a special challenge about it.

Tricky composition, bad weather, or extra distractions. I explain the problems as I go, and you can be a judge of my success in pushing through them. The drawings act as examples of the pep talks.

In the brief time since its first publication, I have happily discovered that this book appeals to artists of all ages, including younger artists still in school. So look for the blue letters and the ★ symbol for my new tips, added especially for you. Read all the other tips too.

So this is not as much a book of how to draw and sketch, but rather why you should. And how to approach the process. See the world as a close observer, and be an artist.

My drawings are for me finished products. For others, a drawing is a place to start, and a study for another artwork that is finished in a studio. Whatever one's philosophical and artistic viewpoint, one can never go wrong by observing and appreciating the world as it passes by. Currently, my finished art form is the book that you hold in your hands.

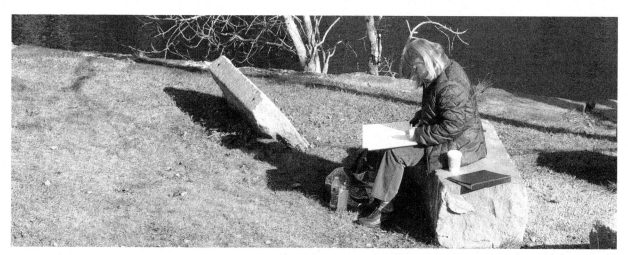

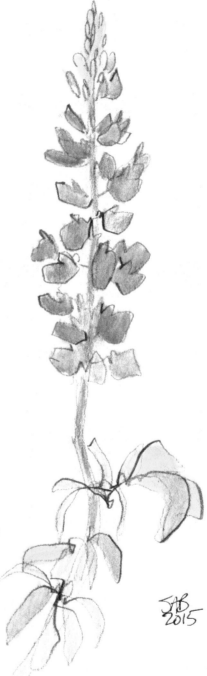

The day was warm and sunny. A gentle breeze was making the purple lupines dance. We were a small group, all drawing together. Looking closely at something beautiful is my favorite form of meditation. Drawing it captures the memory clearly.

Start small and close at hand.

PICK UP ANY DRAWING TOOL

Really, grab a 2B pencil, the ballpoint pen from your bank, a marker fat or thin.

If you wish, carry it in your hand for a while, an hour or two, a day or two. Hold it until it feels like a part of your hand and arm.

After a bit of time, an hour or a day, reach for a sheet of paper. Lined or not, the back of the grocery list, a scrap from the mail, maybe an envelope. A cocktail napkin in a bar, an old fashioned brown paper bag.

Make marks on this paper with your chosen art tool. Vary the pressure from your arm to make light then darker then very dark lines. You might be causing dents in the paper by now.

Vary the angles; vary the lengths. You might be sketching something in front of you or maybe just exploring mark making, as we artists call it.

Find a different art tool. Repeat the process.

Bunch your lines up and then spread them out. There is no wrong way and I will not sneak up behind you. Date the experiments. Sign your name if you wish. Thank yourself.

I prefer to use mixed media for my drawings— usually pencil, then pen, then some color. You will find your own way.

If you forget your sketchpad, draw anyway.

Most of my drawings are done in my sketchbook. But not all. Sometimes you have to use what you have. Above is a simple sketch of a woodland view, on a paper bag.

A white envelope was all I had to sketch on. But I loved the view of the snowy field, seen from a nearby restaurant. And the blue and white envelope liner almost looks like snowflakes.

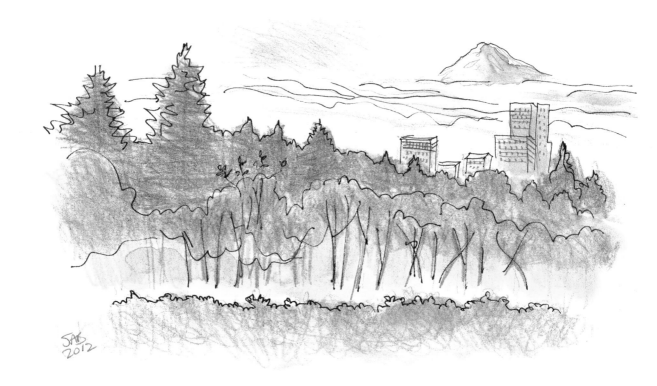

PORTLAND, OREGON

The volcanic peak of Mount Hood rose up through the clouds and fog. As
a majestic peak should. The city's Japanese Garden provided this vista. It
perches on a very high hill overlooking the entire valley. The yellow color of
the sun was backlighting a row of slender trees. The colors were soft and like
all weather, a fleeting glimpse of beauty.

STARTING POINT

Where to start? Not how to start, but where on the page.

You can start in the center with a large solid object and draw around it on all sides, working your way out.

You could draw a skyline and work your way down.

Or sketch the pavement and street and go upwards.

Or attack the paper from the edges. And head inwards.

You see, it depends on the subject matter, your mood, and what seems the most important part of the drawing. On this day.

Return another day, and draw it in a new and different way.

STAND UP

Learn to draw standing up with your small sized drawing pad. It is a very useful skill. If you happen to view something that needs to be drawn in a flash, you will be ready. Like a jack rabbit I drew in Canada.

When you draw on your feet, you are able to shift your viewpoint slightly by swaying.

No one suspects that you are drawing if you stand. That can be a good thing. With my small pad in hand, standing, and making marks on the paper, I have been confused for a building site manager, a city inspector, and a parking police lady.

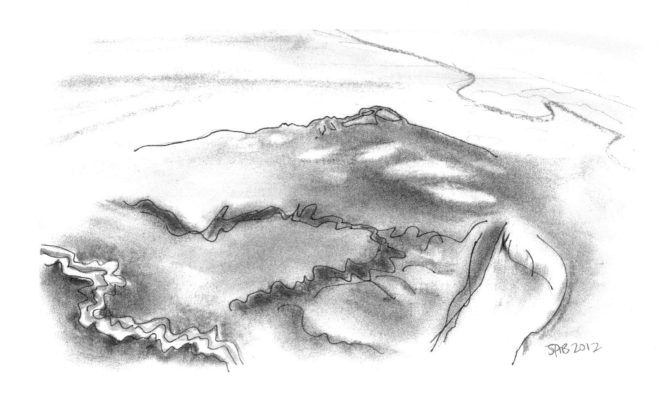

WESTERN US, FROM THE AIR

I love the window seat. It is not unusual for me to get a crick in my neck from gazing at the cloud formation and earth shapes for hours on end. This sketch of somewhere in the American West began with a line drawing in pencil. The airplane wing, the volcano, and the rivers and canyons spread out before me. Later in the day, on the ground, I added ink, and a little watercolor for the rainbow. The grey tones are soft vine charcoal. This drawing helps me to remember the anticipation of seeing our family in California.

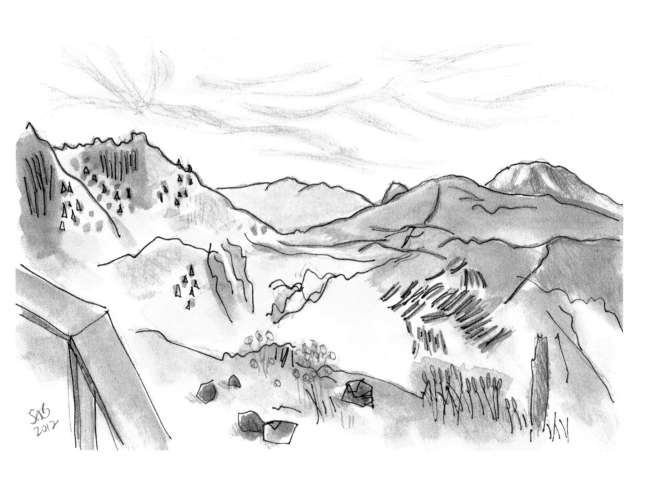

MOUNT SAINT HELENS, WASHINGTON

The volcanic peak in Washington blew its top in 1980. Spending the day in 2012 learning about the new geology of the area, my drawing had to tell the story. The fallen timbers all lined up like matchsticks, the new growth trees on the left, the rocks in the foreground spewed out with the lava and ash. Scientists are amazed at the rapid reappearance of life forms, starting with ants. I should have added a few of the tiny insects.

BE REASONABLE

Choose materials, tools, methods, and styles to suit the time available. Know that you will have differing amounts of time to sketch. A five-minute window perhaps one day. Thirty minutes or, just maybe, an hour the next.

Have a plan. Get a plan by experimenting and noting the time you spent on a particular drawing. It will be a measurement for what you can expect to be able to do with the same drawing 'window'.

Five to ten minutes? A quick pen or pencil study, maybe one continuous line for extra fun. Probably your lines will look jagged and wobbly and will show the time constraint. I love those kinds of emotionally intense drawings.

Longer time? Larger paper, more layers, more careful shading, maybe a panorama.

ACCEPT CONFUSION

Yes, virtually all of the time, a sketcher is uncertain how a drawing will turn out. That is the nature of the beast. And the thrill and the fun, so live with the emotion.

That is why we sketchers follow our hearts, start anyway, try anyway, and enjoy the process.

The finished product, a drawing, is a record of our time spent looking, seeing, recording. And being filled with wonder and amazement at the process, the product, and the world.

Sketchers love life. They have the urge to explore, and then share with others.

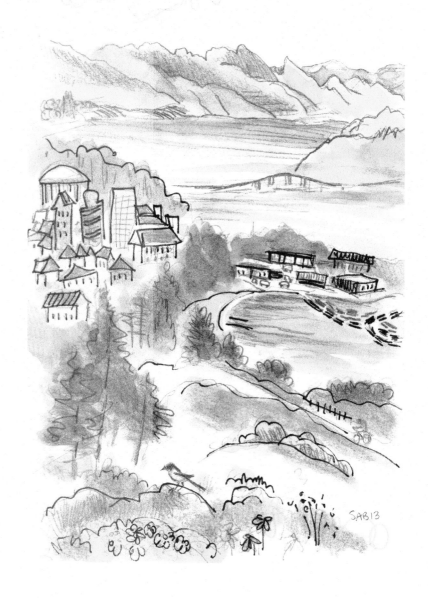

KELOWNA, BRITISH COLUMBIA, CANADA

The city nestles along the beautiful Lake Okanagan in British Columbia. The view from Knox Mountain shows it all, and I wanted to draw it all, daunting as that seemed to me. The black and white magpie sets the scale for the foreground. The city rooftops and floating logs make up the middle ground. The steep hillsides, covered with vineyards, disappear into the distance.

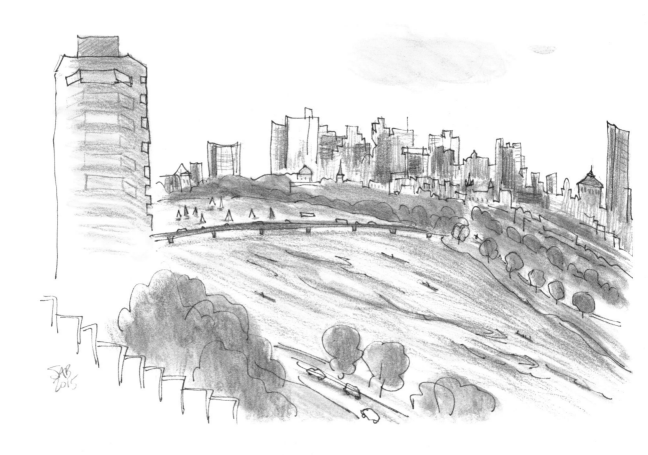

BOSTON, MASSACHUSETTS

Panoramas are so tempting. And here I was on the twelfth floor of a hotel overlooking the Charles River and the city. Squinting and very careful looking needs to happen. And a lot of picking and choosing too. Iconic buildings have to be there, like the State House with its golden dome. And the red brick townhouses in Back Bay. And sailboats and scullers are required too.

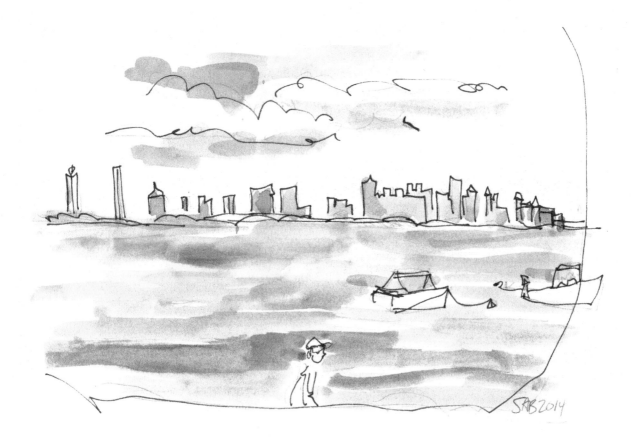

BOSTON, MASSACHUSETTS

We got lost returning from the South Shore, but our wrong turn gave us
a splendid view of Boston Harbor. I drew it quickly from the car, letting
the window edge become the picture frame. If you know Boston, you
can probably recognize a few buildings. The plane is just about to land at
Logan airport. This is one of my drawings where I feel that the lines need
the color, and the color needs the lines.

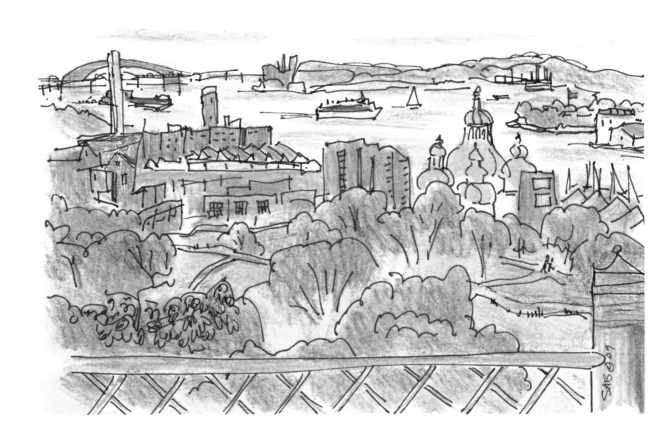

BALTIMORE, MARYLAND

I climbed the Pagoda in Patterson Park to get this splendid view of Baltimore Harbor. The wind was whipping my hair. For depth and a sense of place I drew the railing, then down to the footpaths with several ant sized people. Fort McHenry is on the right with the flag pole. This is the location of the battle in the War of 1812 which inspired Francis Scott Key to pen the National Anthem.

LISTEN UP

Become aware of other senses that are heightened while you draw. List them.

You may notice music from a house, car, restaurant, live band, a wandering minstrel.

You will detect aromas and odors. Lilacs, apple blossoms, autumn leaves, exhaust from traffic, cooking smells like pizza, onions, Chinese food.

Pay attention to sounds as you draw. Falling water, barking dogs, wind flapping the canvas sails, people chatting as they walk past you, rain on the restaurant roof, a car shifting down around the sharp turn.

Of course you will savor your lunch, snack, or afternoon tea, perhaps while you are sketching. If you spill food or drink on the drawing, keep going. It will add to the memory layers.

You might taste the salt air near the coast or chew on gritty dust in a dry dessert place.

The crowds in a market square might jostle you, shake your drawing arm, or pay you a compliment.

You will remember the sensual feel of the paper in your sketchpad and the smoothness of the marker against the white sheet.

DRAW WHAT YOU LOVE

Focus on what appeals to you most. Forget what you 'should draw'. Your drawings will be very personal, which means that only you could have created them.

Your art will mean a lot to you first. Then it will mean a lot to others.

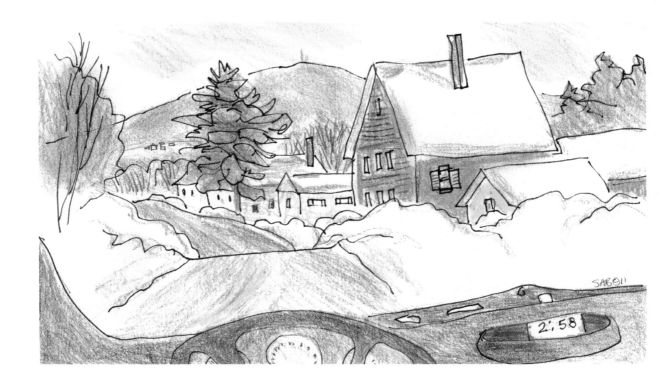

NEW LONDON, NEW HAMPSHIRE

It was a cold day, but Mount Kearsarge looked sharp and blue. As you can see, I decided to draw it from the inside of my car. The car window makes a natural frame for the sketch. And we have the time recorded too. Winter drawings are nice to do, but it helps to have shelter.

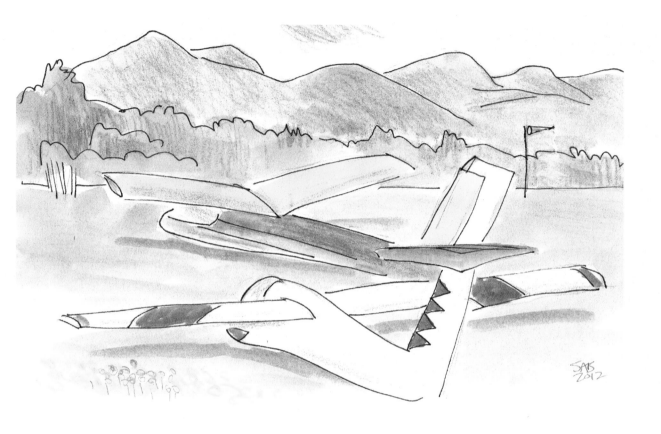

FRANCONIA, NEW HAMPSHIRE

Gliders on the ground; that is a new sight for me. Everyone has seen them high in the air, soaring like eagles. I was amazed to notice that the two gliders had very different designs evident in their tails and wing shapes. Sketching can be very educational. I still have no desire to go up into the skies in one of these beauties.

AH, CRAYONS

It is important to remember drawing as a child. Go back as far into your memory as you can. Recall the waxy smell of a box of crayons. Bring back a vision of a messy and fun finger painting session.

Remember being lost in the moment.

★ For younger artists, this advice is for older people. You are already in the middle of your first years of exploring art materials. Keep it up.

DRUM OUT THE LITTLE VOICES

Use music or some kind of white noise or pleasing sound to quiet the negative thoughts that float around in the head. Art making should be quiet, focused, and without much talking from others. And without a lot of internal monologue either.

When you get to this zen place, you lose track of time and anything else that was on your to-do list.

PROCESS VS. PRODUCT

Drawing is a form of looking carefully, seeing with new eyes, and recording your discoveries.

If you learn to enjoy the process, the end product will take of itself. Go for quantity. Your work will improve with practice.

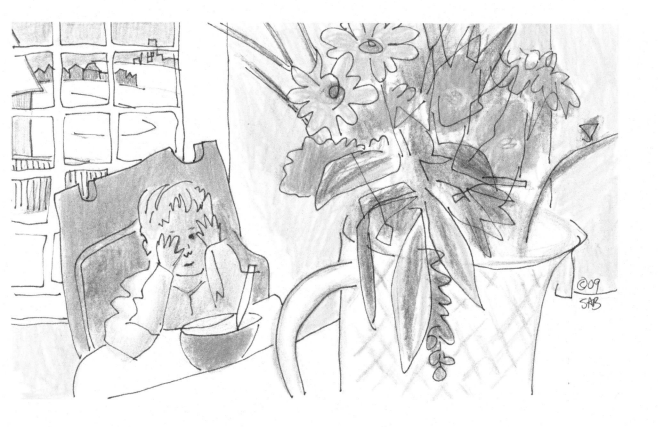

EDMONTON, ALBERTA, CANADA

Our grandson was almost two years old. A few months had passed since we had seen each other, so he was a little shy. We were warming up to each other by playing peek-a-boo, that classic game. Some of the time I was concealing my face behind the vase of flowers. It is not a perfect likeness of the flowers or the child, but a wonderful remembrance of the day.

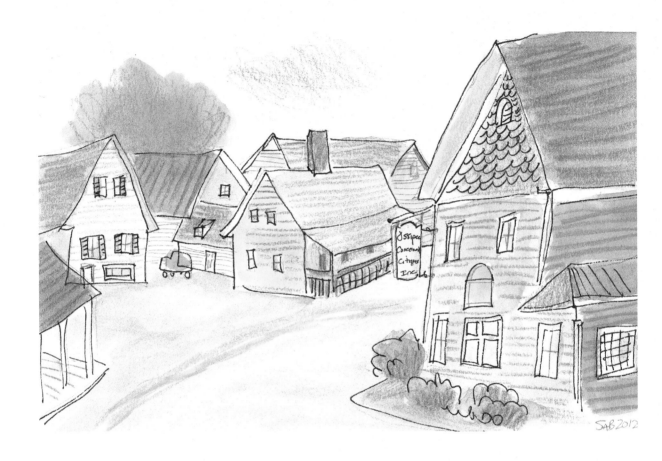

OSSIPPEE, NEW HAMPSHIRE

The challenge this day was overcoming fatigue and confusion. We got lost several times driving around this spread out town with its many villages. I settled down in this corner square because of the colors. Bright colors calm me down, as well as perk me up. They give me a focus. I can read both excitement and also some exasperation in my linework. It is quite acceptable to include emotions into your drawings.

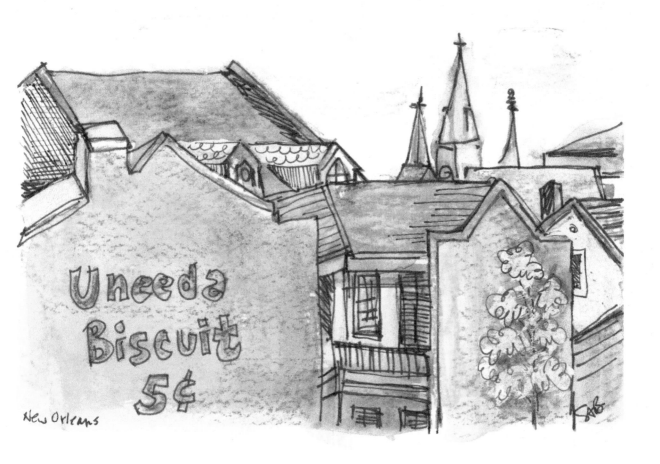

NEW ORLEANS, LOUISIANA

I remember peering through our hotel window and admiring this view of the French Quarter. Our family trip was almost thirty years ago, but this sketch helps refresh my memories. The famed Jackson Square church spires are just poking up in the background. How charming is that old advertisement painted on the brick wall? I strongly advise sketching the view from your hotel window when you travel. No matter what the view is.

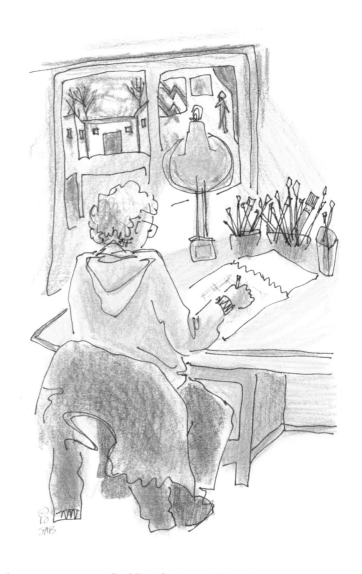

ELLICOTT CITY, MARYLAND

Artists in their studios fascinate me. They are surrounded by their creations in a place they love. My friend Mary Jo Tydlacka sits at her drawing table. In the background are the sketches she uses to help plan her paintings. A drawing or sketch may be either a finished product, an exploration of composition, a study for architectural details. Or a recording of an event, called a reportage drawing.

NAME THAT NEMESIS

List your three greatest fears/worries/concerns/blocks/hangups/negative thoughts about keeping a sketchpad and drawing the world.

Make another list of people who have discouraged you. Write their names really small, whether cranky art professors, siblings, or grinchy former bosses or any other kind of ex.

Crumple up your lists. What you do next is up to you. Gaze upon the woggled up sheets of paper, recycle them, toss them into the fireplace, flatten them under your foot. Compost for the garden.

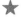 For younger artists, don't let anyone discourage you. Your art is important and a part of your view of the world.

I MOVE MOUNTAINS

Observe a scene carefully and decide to sketch it. While you are drawing it, decide to improve upon it. Make the mountain bigger, move it to the left or right for a better sightline.

Chop down a few trees to see a handsome building more clearly. Turn the wind and make the flag flap in the other direction. Nobody notices. You are the boss with your pen or pencil. Enjoy the freedom.

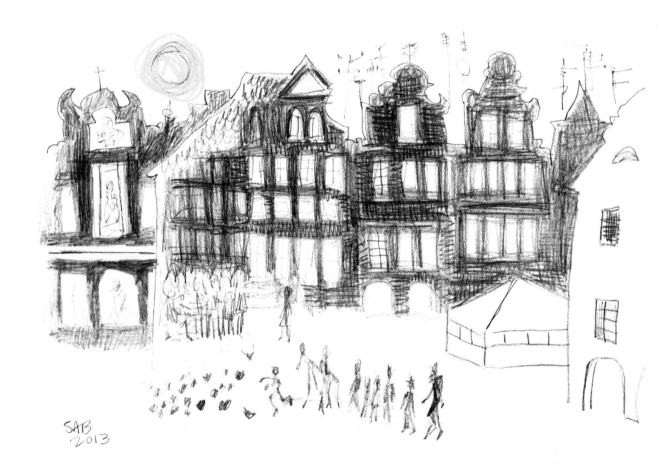

POZNAŃ, POLAND

Visitors were gathering in the large city square to wait for the clock to chime and a couple of goat statues to butt heads in the bell tower. The tall ornate buildings were extremely colorful, all yellows, pinks, blues, and pale greens too. But the sun was in my eyes, and I made the decision to just use my pencil to depict the scene. Each drawing has all sorts of choices like this, and that adds to the enjoyment of the process.

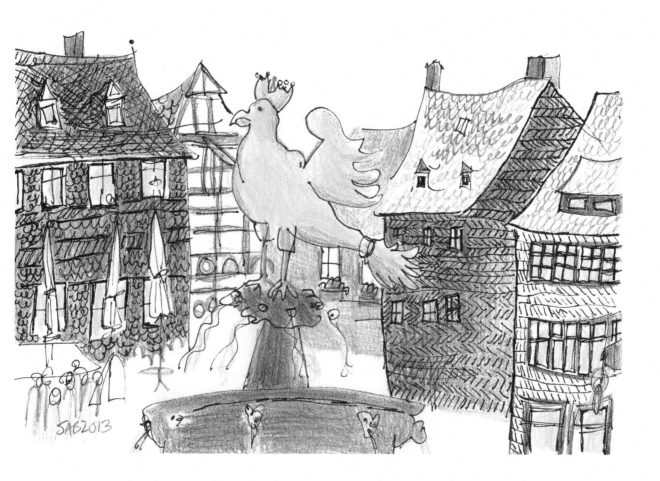

GOSLAR, GERMANY

Standing in the middle of the square, I was enchanted by the crowned gold
eagle atop the fountain. Decorative slate tiles cover the background buildings
on all sides and the roofs. Would they be at all understandable, readable, nice
to look at? I had to go with my gut on this one. I lightened the grey tone on
some of them to balance the composition.

LOVE WHAT HAPPENS

Learn to love smudges, smears, mistakes, and imperfections. As we all know, unexpected things happen. In life, and on the drawing pad.

Accept any ink splats, coffee spills, rain drops, false starts, and general mess ups.

Keep going, shutting out all the little voices. Start over occasionally, not often.

Sometimes I begin a drawing again when I have not carefully considered whether the scene wants to be a horizontal or a vertical.

Sketch lightly in pencil first if you wish to get your bearings. Follow that with darker strokes, colored pencil, ink, whatever you wish.

I think in layers. Layering one color over another to build richness. My thoughts usually include something like 'eventually, this will come out right'.

Then learn to know when to stop. Learn to sense when the drawing is done. Listen to your gut. I stop when my hand hovers, and hesitates, and slows down.

24 HOURS IN A DAY

List five reasons that you don't have time to sketch or draw today. Make them full sentences.

You'll see where I am going with this. By the time you've finished your list, you could have completed a quick line study. Few lines or even just one can capture a scene, a moment, a day in your life.

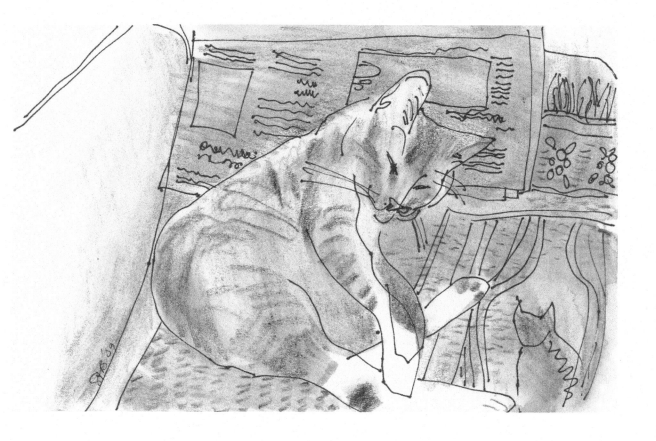

BALTIMORE, MARYLAND

What is it about cats and newspapers? I wasn't sure if Simon would lie still or
squirm about. Our good natured, gentle cat had just been diagnosed with a
serious illness when I sketched this. And perhaps his days were numbered. With
medication, he did live quite a bit longer, but I always remember the bittersweet
time when looking at this drawing.

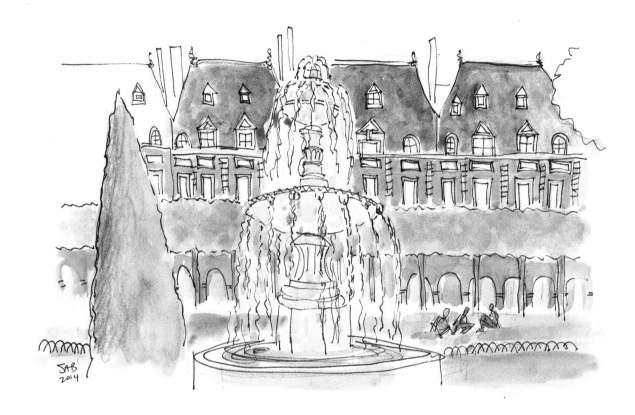

PARIS, FRANCE

Urban parks fascinate me. Their geometry appeals to me, as well as the people who enjoy them. La Place des Vosges is an elegant square of symmetry and complexity. The brick and stone buildings surrounding the lawn have a calming effect. As does the flowing water of classical fountains. We had just finished our tri-flavored gelatos. See how a drawing brings it all back?

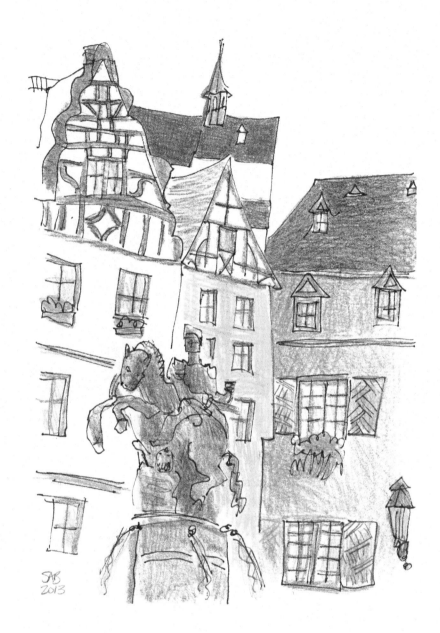

COCHEM, GERMANY

The lights were coming on and as dusk approached, crowds of people surged into the square. It was bar hopping time. As for me, it was sketching time in low light, jostled by crowds and hearing music from several competing cafés. I love having to keep a sharp focus like that while life swirls around me. The equestrian statue fills the center of the page. Drawing horses scares me.

CHÂTENOIS, FRANCE

After a series of careful, slow, detailed drawings, it is always exhilarating to grab a marker and sketch rapidly. Scarcely taking a breath. No seatbelt, no helmet. I sat in a little public park and drew the ancient rooflines, towers, and turrets in red. Then I added a wall, windows, a stone gate, and a stork's nest in blue. Is it readable and understandable? It is a strong memory for me.

BELIEVE YOUR EYES

Believe what your eyes are telling you, not your brain. Look at sizes and proportions carefully. In most instances, whatever is closest to you will be larger than the more distant stuff.

For example, the cat in the near foreground may well look larger than the person or the house or the mountain in the distance. Draw it as you see it.

It is useful to do a quick measurement of proportion. Is that building wider than it is tall? Twice as wide?

I pay very little attention to perspective and vanishing points. Put one object in front of another. That alone will indicate depth.

I have a natural tendency to draw objects tall and thinner and more vertical in feel than they actually are. Sometimes I make a few eyeball measurements to avoid this distortion. Other times I let it happen.

TRY ON A STYLE

Copy another person's style. Notice how your own style will assert itself.

Find an artist you admire in a museum, or from a book. Tell yourself what you admire about this style. Is it the color, line, shapes, abstractions, energy, humor, messiness, neatness?

Then start a drawing of your own, copying the style, subject matter, or both. About half way through the drawing session, feel your own way of seeing begin to poke through. Keep letting go of the original art; perhaps turn away or shut the book. Then finish in your own fashion, in the way your brain, eyes, and heart wish to speak.

LAWRENCE, MASSACHUSETTS

Talk about texture and pattern.
I found them both in abundance
at the Lawrence Machine Shop.
The soft black edges of the
stones in the smokestack were
drawn with a soft vine charcoal
stick. Smudgy lines can be very
useful. My drawings have been
filled with windows and doors
since I was a child. The three
clouds at the top were designed
as a repetition of the three cars
at the bottom.

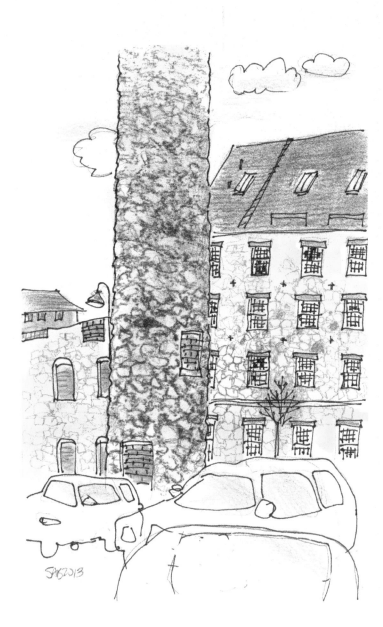

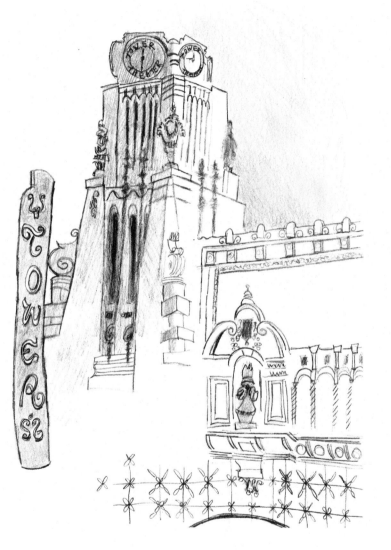

LOS ANGELES, CALIFORNIA

The very warm day had a royal blue sky. The white, terra cotta tiled building was across the street from my seat on a low wall. I had to throw my head back to see the top of the art deco styled theater on Broadway. Which made for considerable squinting and brow mopping. But I loved the complexity and the decorative floral designs. The lettering on the sign was distinctive with its challenging font.

MACROCOSM

Find something very large and draw it
very small.

Draw a mountain range, a prairie, or a long horizon.
Sketch a lake or body of water, focusing on wave
patterns and ripples.

Draw a harbor full of boats. It doesn't matter a bit if
you know or don't know anything about boats. If you
own a boat, draw it.

Look up in a city and draw the buildings against
the clouds.

Find a roof top and look down onto the street level.
Draw the pattern of vehicles stopping at the signals.

Do the best you can on this day.

MICROCOSM

Draw something small very large. Fill your
drawing page with your sketch. Find an
object that is both small and complex.

Some examples of this are an insect, a shell,
wrapped candy, jewelry, a piece of popcorn, a twig.

Exult in the details you never noticed before. Enjoy
the time spent looking.

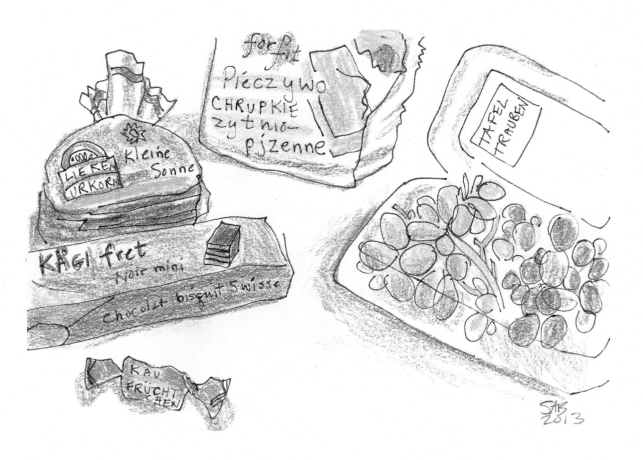

JETTINGEN-SCHEPPACH, GERMANY

After drawing long vistas, busy medieval town squares, and soaring church spires, small objects close at hand are a pleasant change. These five snack items were traveling along with us. I count three languages, Polish, French, and German. Arranging them to form a pleasing design is the first step. Then comes very careful copying of the languages on the labels. The drawing brings the travel adventure all back.

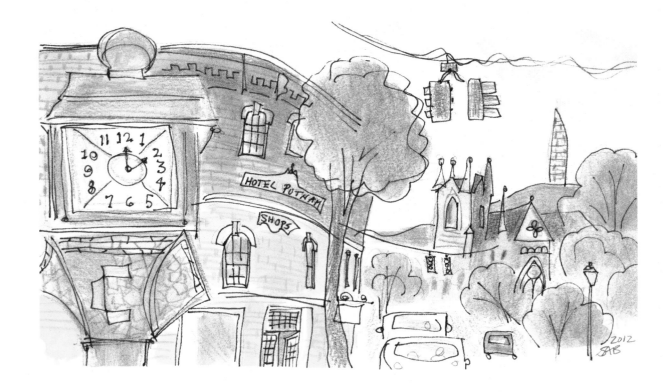

BENNINGTON, VERMONT

This corner intersection has all the ingredients that cause me to pull out my sketchpad. A brick building with a curved wall. Yellow paint on a curved wall. An oddity like the sidewalk clock made of stained glass. The grey stone church had a nice tower with spiky little turrets. And then in the distance, the Bennington Monument obelisk, which I enlarged so it would look more impressive.

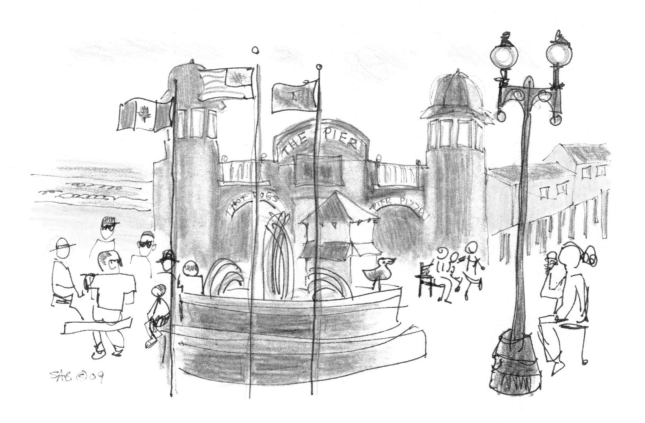

OLD ORCHARD BEACH, MAINE

At the very last minute, I decided to draw this scene at the old seaside resort. The whole family was waiting for me in a hot car in a nearby parking lot. That means a very fast drawing, in pen, with no preliminary planning with a pencil. I made mental color notes and filled it in as soon as we got home. The sketch has a fresh feeling to it, brought about by the frenzy of a short time limit.

NÜRNBERG, GERMANY

It seemed essential to me to draw the view out of the window of Albrecht Dürer's studio. I had only minutes, as the family was already several rooms ahead of me in the house tour. The windows frame the ancient town walls. I was standing and hurrying, and it doesn't matter if the finished sketch shows my emotional state either. It was thrilling to just be in the printmaking studio of a genius.

GIVE UP NAPPING

How do sketchers find the time to draw when traveling with non-sketchers? Like your dear friends and family?

Sketch when others are relaxing or otherwise occupied. When they do not need you for anything.

When others nap, you draw. Art is restorative.

When others shop, draw the markets. This will save money, as drawings are by far the best souvenir of a trip.

Draw during mealtime. This is the food you didn't have to prepare, so you will have extra energy. Sketch the labels of the local brews. Or wine bottles from the vineyard within sight.

If you shop for food and then cook your meals in a rented cottage, draw the food and your borrowed kitchen.

Draw the dials and instructions on European dishwashers and washing machines, which are totally baffling.

If your family spends time on a beach, bring a sketchpad instead of a summer read.

★ For younger artists, this book emphasizes the kind of drawings that come from direct observation. Other kinds of drawings can come from memory or imagination. Many artists like to do all three kinds. If your inspiration starts by copying a design that inspires you, make it your own by changing most of it.

PORTSMOUTH, NEW HAMPSHIRE

This doorway is an urban delight for the eyes. When I draw something like this, I want to express my appreciation to the architect as well as the craftsmen who did the actual woodworking and glass cutting. Think of the skilled people who made the panes of glass. My mind can wander like this for a long time while sketching.

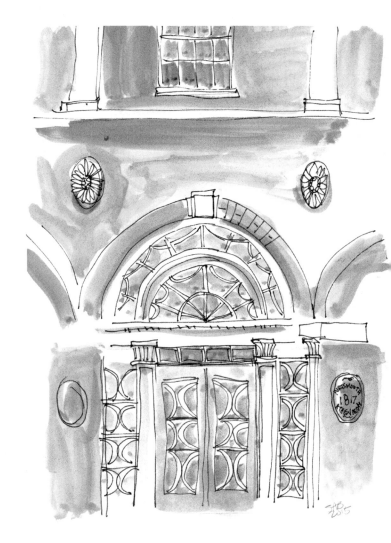

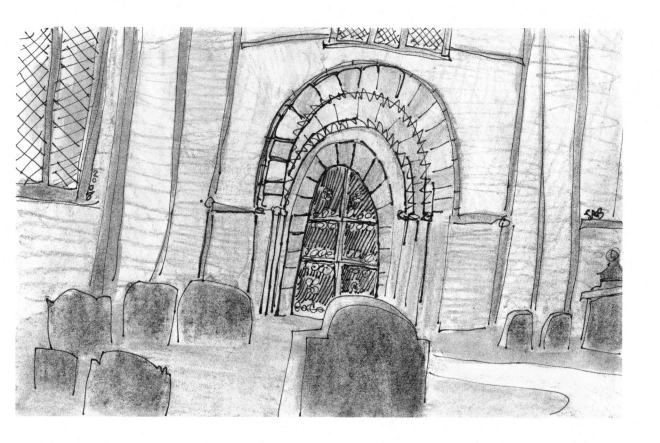

LEDBURY, ENGLAND

I stepped out the door of our rented cottage and started up the cobbled lane
to the sound of the bells. The curved grave stones and the arched doorway of
the church struck me as a potential drawing. Repetition of shapes is the glue
to a strong composition. The warm reddish façade contrasts with the cool grey
of the slate markers. The peaceful scene was lost in time.

RECONNECT WITH YOUR PAST LOVES

What fascinated you as a child? You probably filled page after page with colorful drawings of this subject.

Did you draw cars, rocket ships, motorcycles, airplanes? Flowers, trees, plants? Animals—large, small, fluffy, scary, monstrous?

Go to an airport, large or small. Drop by a Friday night car buff group at your local drive through food place. Or visit an arboretum, nursery, favorite park, or your own patch of earth.

Maybe draw the turkeys that wander through your yard, the birds at your feeder, your dog sleeping by the fire.

Draw with a loving eye for detail where it seems essential for the subject. And ease up on some details you care less about.

 For younger artists, you are still developing your interests. Keep a sketchbook to record your changing and deepening interests.

MIX IT UP

Do a line drawing with pencil, or pen. Or fine marker or soft charcoal if you have them and are in the mood.

Choose a subject that really appeals to you and seems to tug at your heart.

After the line drawing is finished, find one area of the composition that seems like the heart, and add bright vibrant color. Use colored pencils or crayon or lipstick. Whatever you have.

Date the drawing and add two or three words to go with it if you wish.

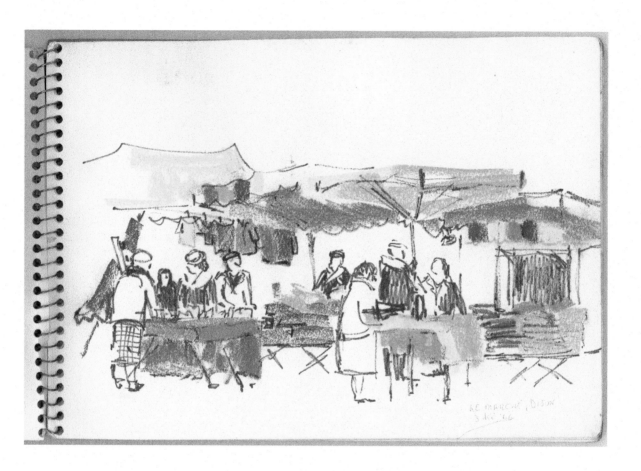

DIJON, FRANCE

It was cold enough to freeze the felt tip in my marker. That explains the grey lines, which might have been black on a warmer day. The colorful canvas awnings caught my eye, as well as the bundled up, formally dressed customers. This drawing was done in 1966 when I was a university student in France. I had never seen an outdoor market before, never seen spices in barrels, skinned rabbits hanging up, or cheeses by the wheel.

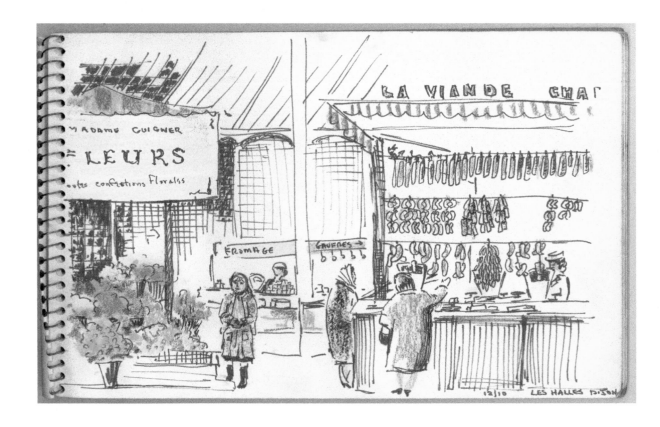

DIJON, FRANCE

When I lived in France in the 1960s, Saturday meant a walk to the downtown market. I soon learned how many purchases could comfortably be lugged back in my string bag to my apartment, a couple of miles away. In the indoor market, the flower seller wears her boots, and the ladies choosing sausages are dressed in heels, warm coats, and kerchiefs.

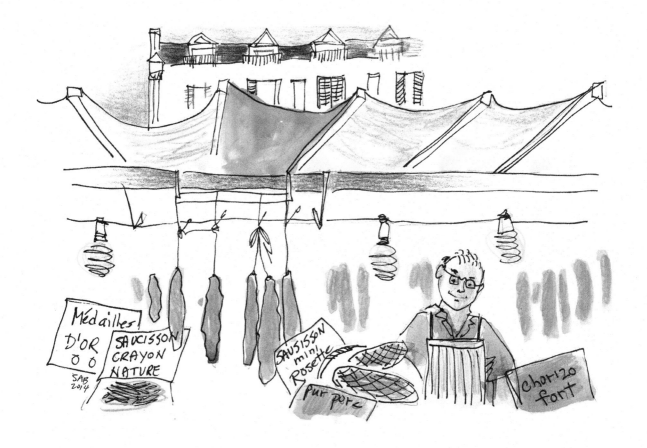

PARIS, FRANCE

The Sunday market was bustling, and my back leaned against a tent pole. The unusually warm sunny day had brought out the crowds. American style jazz music swirled in the air. I love theme and variation, and there it is in all the varieties and shapes of the smoked meats. I received a broad smile from the vendor when holding up the drawing.

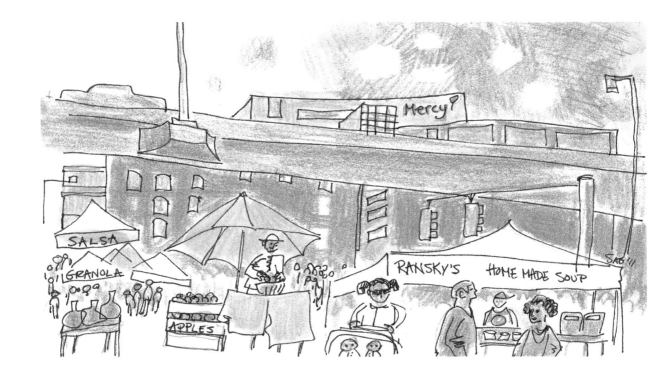

BALTIMORE, MARYLAND

Street markets offer a huge range of subjects to draw. And people are very busy and pay you no mind, usually. I sat on a curb and sketched several vendors' tents. Then the choice of shoppers and babies. Next came the overhead highway, an unusual perspective of a city street for sure. If I lived near this market I would be there sketching every Saturday.

GET STUBBORN

Carry your sketchbook and pen or pencil, or colored pencils, and then use them. Look for chances to use them. Think ahead for possibilities.

Say to yourself, "I refuse to carry this around with me all day without taking the time to open it up." Be firm with yourself. Do not postpone fun.

Here's another, "I refuse to be so busy/preoccupied/scattered that I feel I can't slow down and take a few minutes to look up, see my world, appreciate it, and connect with it."

GET SELF-IMPORTANT

You have to believe that it is important that you draw. That you sketch that scene today, that very sunrise, that animal track in the snow, that wind-scarred tree, that family gathering, that building demolition, that reconstruction that saves the old mill.

A drawing is your document that you are here, have the eyes, the heart, the will, and the need to record. For yourself and for others.

GET BRAVE

Show your drawings, your sketchpad, to anyone who seems even slightly interested. Share the results of your efforts and be willing to accept praise. Explain your goals. Take encouragement from kind words. This will all become part of the memory that's wrapped up in that drawing.

Encourage is a French word which has the word heart, *coeur*, in the middle of it. Should any discouraging words come your way, just sigh, smile, and then go on your merry way with no backwards glances.

Invite others to come sketching with you.

BOSTON, MASSACHUSETTS

From my rather cold seat on a
stone bench, I looked up and
drew the newish buildings along
the waterfront. The varieties
in the styles and shapes of the
windows pleased me. As another
experiment in drawing the near
and the far, a chain was included
in the foreground. Then I had
second thoughts about that. It
looked forbidding, so the tone
was lightened on the right.

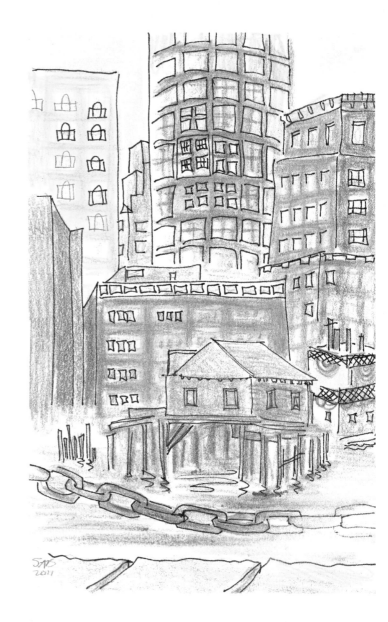

LOS ANGELES, CALIFORNIA

The composition was going to be challenging for sure. I was in the sitting area of an open garden atop a high rise. My view was looking down on a construction site with a massive crane. The flat rooftops of some older buildings made up the foreground. A lot of simplifying was required, but I like to pick and choose my favorite details.

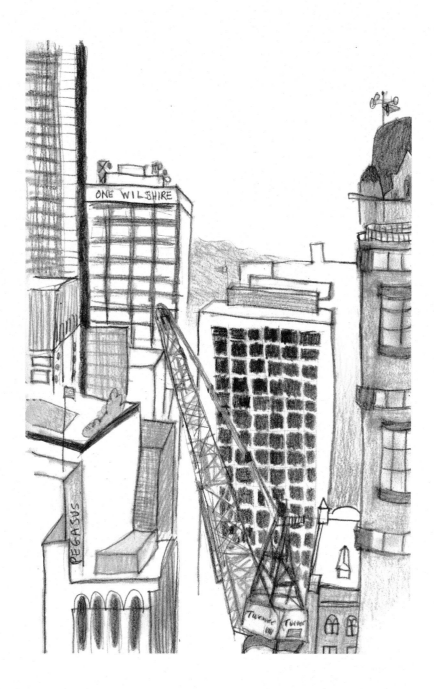

GET FEISTY

Get persistent and yet flexible too. A car or van drives up and parks in front of the scene you are sketching. Just include the vehicle, and remember that you are capturing a moment in time. Try making the van transparent just for fun.

The chosen day for a sketching session is rainy. Draw from your car, from a window seat in a cozy café, under an overhang, or let a good kind friend hold an umbrella over your head, and the paper.

Are you feeling ambitious and want to draw a big landscape or urban skyline, but don't have the all important chunk of time? Return to the spot once a week. Layer on any changes you note from one week to the next.

Draw a sunset in a series of tiny sketches. From the first colors to dusk. Try drawing in the gloaming, as the Scots call it. In the dusk. If you wish to draw in the dark, then street lights, the moon, and a small booklight are very helpful.

Get warm gloves and draw in the winter. If you need them where you live.

Buy a purse or backpack that easily can contain your sketchbook and tools. Pay no attention to fashion.

★ For younger artists, draw your world, your friends, your teammates, your lunch, family, and favorite food. Your sketchbook is a visual diary.

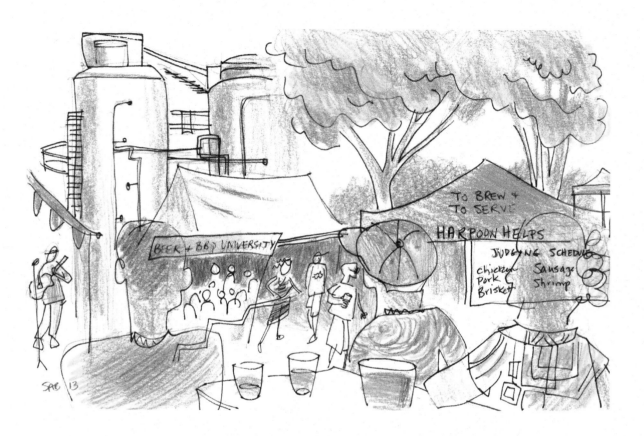

WINDSOR, VERMONT

Music, food and drink, crowds, and a brewery: yup, it's an ale festival. My small sketching paper was in my lap, hidden from view. The musicians were talented, lively, and holding everyone's attention. It is useful, and rather fun, to make people and objects transparent. More details can be jammed into a small composition that way.

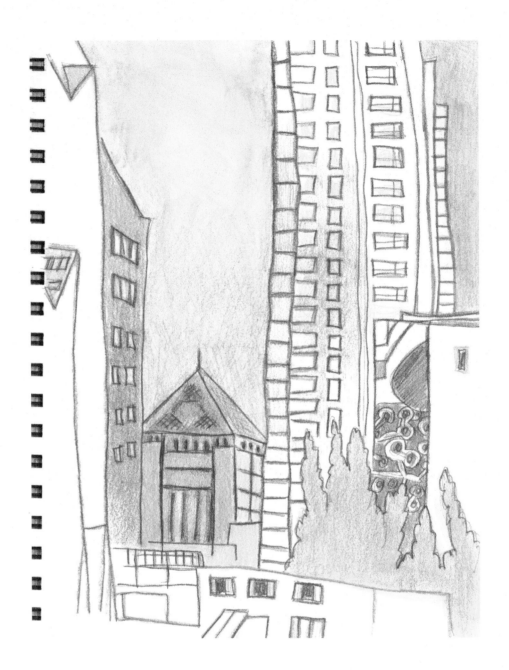

LOS ANGELES, CALIFORNIA

Downtown Los Angeles is a study in contrasts, as this view from my daughter's apartment illustrates. The tall buildings are new features in the Financial District. The Art Deco style City Library peeks through with its mosaic covered triangular roof. The negative shapes of the blue California sky are important design elements.

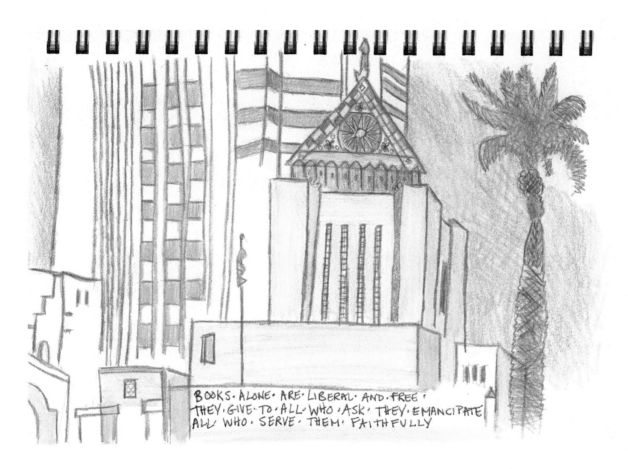

The inscription in the drawing reads:

BOOKS · ALONE · ARE · LIBERAL · AND · FREE ·
THEY · GIVE · TO · ALL · WHO · ASK · THEY · EMANCIPATE
ALL · WHO · SERVE · THEM · FAITHFULLY

LOS ANGELES, CALIFORNIA

When you find something to sketch, try walking around. Study all the different angles. Notice how the shapes change with the slightest shift of your feet. You could draw something ten times and compare them all. The series will tell a story. This view of the Los Angeles City Library is close enough to read and record the inscription over the door.

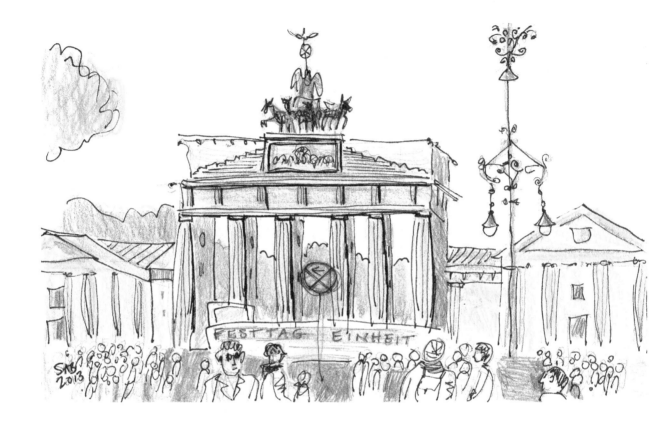

BERLIN, GERMANY

I stood on a busy sidewalk sketching this scene in 2013. It was overwhelming, but not because of the crowds. When we lived in Berlin in the 1970s this side of the Brandenburg Gate faced into East Berlin, and we did not go there. We never saw the faces of the horses, just their rears. We never got to walk along the Unter den Linden. And this day we were casually waiting for our walking tour to begin. A person leaned over and quietly said '*schön*' to me. Which means nice. Nice it was.

NEWSWORTHY AND NOT NEWSWORTHY

Is something happening in your town that needs some reportage drawing? By you? A drawing can tell so much more than a photograph. Is an historic building being razed, or perhaps a new red barn being raised up?

Is there a protest or strike or public gathering you could witness with sketchpad and pencil? Are two groups of people carrying signs and glaring at each other?

Do politicians gather in your state by the droves every four years?

Get the images down.

Alternatively, you could find meaning in drawing something small and ordinary. Something you see every day. Your teacup and cookie. The view from your kitchen sink, or the view into the sink.

Your houseplants in the morning sun. The souvenirs from a cruise or a mountain road trip.

A family keepsake that will enjoy your attention.

Get the images down.

BE A SERIAL SKETCHER

Give yourself an assignment. Write it down. Here are a few examples.

The view from every hotel room when traveling, whether an ocean view or an alley.

The view from every room in your house.

Every farmers' market.

Your garden as the seeds begin to sprout.

The day the flowers open—or the day before, when you are waiting.

Draw musicians when you see them. Combining two art forms makes a very strong memory.

Sketch dancers with their graceful moves. Your lines will be graceful too.

Draw ten mountains, or ten mountain ranges.

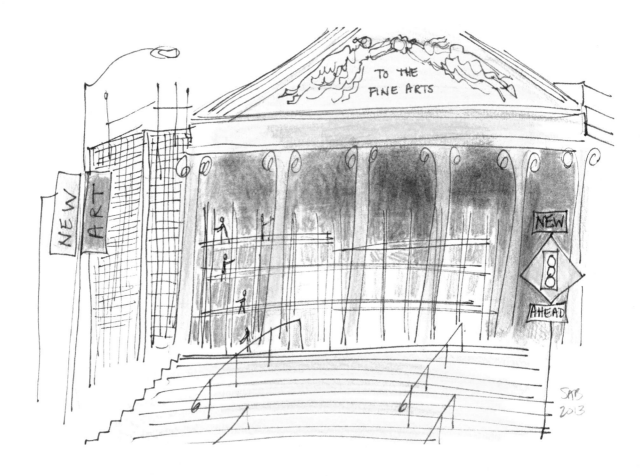

BALTIMORE, MARYLAND

The classical façade of the Baltimore Museum of Art was being surrounded by scaffolding as I walked past. Dozens of construction workers were scurrying around and climbing the bracings. On this day, the museum had a whole new, if temporary, look. It must have looked like this when first being built. The next day, the entire front was wrapped in some type of white fabric. Carry your sketchpad and be ready.

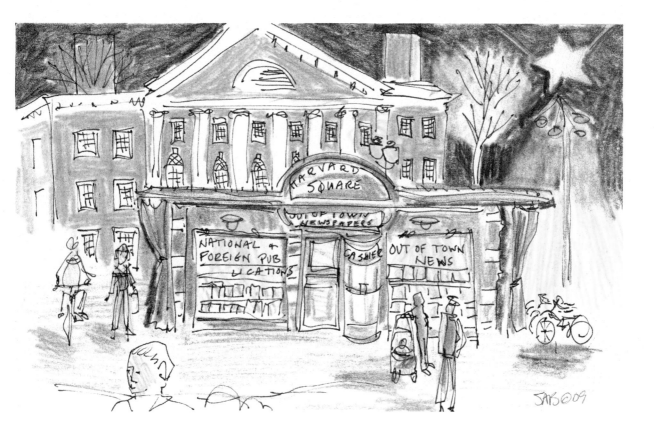

CAMBRIDGE, MASSACHUSETTS

A Christmas star is hanging in the evening sky over Harvard Square. The brick buildings of the Yard are in the background, but my focus is the tiny old news stand. As a teenager, I took the bus to volunteer at Mount Auburn Hospital, and even more important, to buy foreign magazines at this news stand. I was born with a wanderlust. Feeling very emotional while sketching this, the darkness hid my tears.

DRAW FOOD

And I don't mean bowls of fruit.

Draw pizza, birthday cakes with candles, and fresh vegetables on the counter just before you chop them up for supper.

Draw food as it grows, either in your garden or at a nearby farm or garden center. Draw a vineyard.

Draw French pastries anywhere, or even in France.

Sketch a large family meal, before after or during.

Go to food festivals with your sketchpad. Draw the colorful and delicious offerings. Include some crowds. And maybe food on a stick.

Buy produce at a farmers market. While there, draw cabbages, rows of honey and jams, crusty bread loaves, and piles of red radishes.

FOLLOW THE BOUNCING BALL

Challenge yourself by drawing a moving event. Something that is changing position quickly.

Draw a parade. Or capture the motion of choppy water and rocking boats.

Scribble lines depicting bad weather and threatening clouds.

Draw children and dogs running in a park, or little kids chasing pigeons.

Or flocks of birds wheeling in the sky.

Draw horses, llamas, sheep grazing in a field. They move, but slowly. They may come over to see what you are doing, of course, giving you a chance at a closer view.

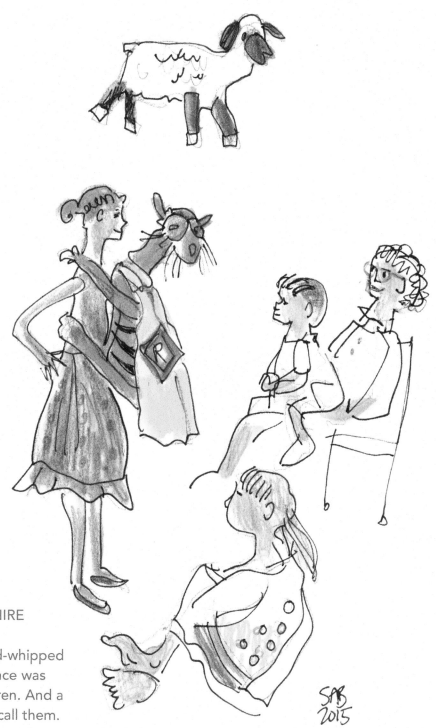

NEW LONDON, NEW HAMPSHIRE

The shady park next to the wind-whipped
lake was the setting. The audience was
hordes of happy, wiggling children. And a
few parents and g'parents, as I call them.
Lindsay Bezich has large and unusual
puppets that hang off of her waist.
I drew the rhyming tiger, with the 'R' on his cape, with all the truthfulness
I could depict. Her storytelling skills, with silly voices and gentle morals,
are admirable.

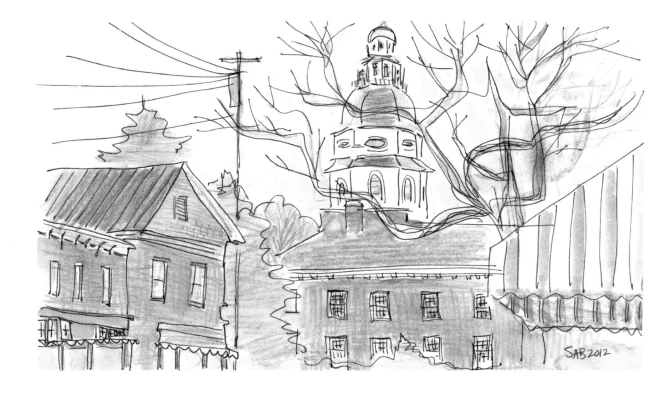

ANNAPOLIS, MARYLAND

The State House dome is beautiful, impressive in scale, and dominates the scene from this side street. So it is a little visual dance for me to include the storefronts, the bare winter branches, the telephone lines, and the awning. My goal is to convey the sense of walking down the cobbled street while catching a glimpse of the dome in the winter season.

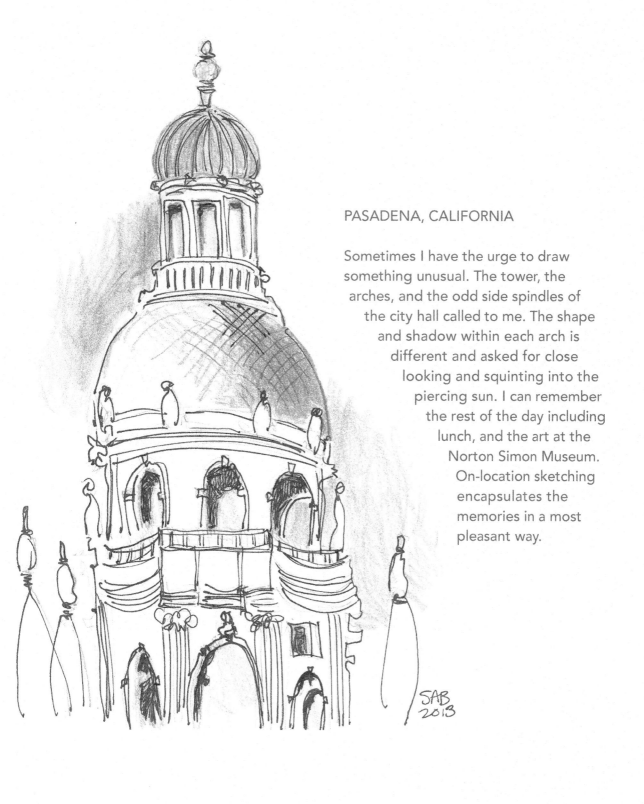

PASADENA, CALIFORNIA

Sometimes I have the urge to draw
something unusual. The tower, the
arches, and the odd side spindles of
the city hall called to me. The shape
and shadow within each arch is
different and asked for close
looking and squinting into the
piercing sun. I can remember
the rest of the day including
lunch, and the art at the
Norton Simon Museum.
On-location sketching
encapsulates the
memories in a most
pleasant way.

SAB
2013

SOME PEOPLE

When you are sketching, the average passer-by will pay no attention to you. (This assumes you have a smallish sketchpad with a small set up, not an easel and a beret.)

The occasional person will sidle up to you to say 'nice' in English or another language. And you will smile, nod, and say 'thank you' in English or another language.

Sometimes a person will say that a family member paints. They are connecting with you, and you again nod and keep going.

Fairly often people will say that they used to draw too. And that they always mean to get back to it but haven't yet. And they sound sad.

This is why I wrote this book.

★ For younger artists, this book is for you too. Believe in yourself, get better by practicing your skills, and be thankful for your talents.

Did I mention that drawing in bed works too? Here is our granddaughter Noelle finishing up a sketch amidst plenty of pillows and cushions for comfort.

I've chosen several more drawings for you, each with a story.

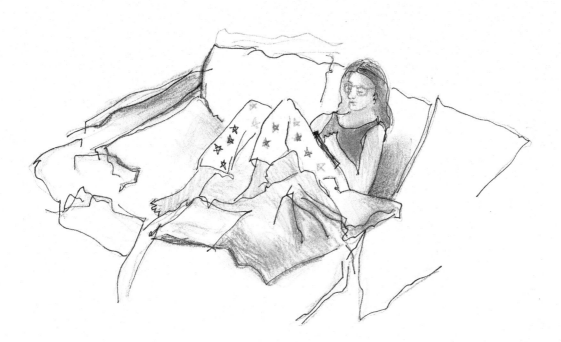

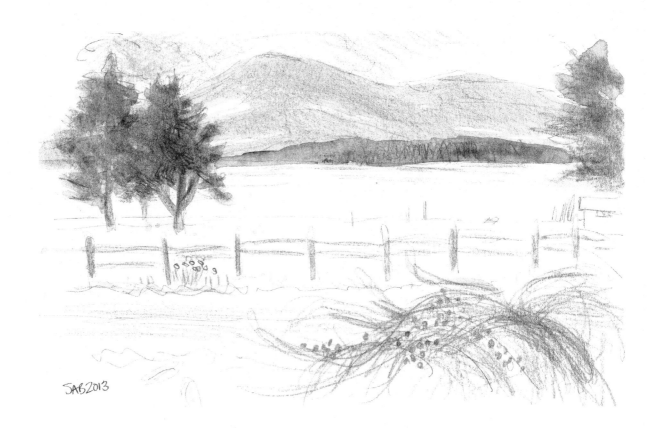

NEW LONDON, NEW HAMPSHIRE

Foreground, middle ground, background. This is my formula for spatial clarity and depth. My only concern here was whether the snow covered and frozen Pleasant Lake would read as a lake. Rather than a large, open field. A couple of ice fishing huts would have solved that issue, but they are not allowed on this lake. In many if not most of my drawings, the viewer has to fill in some of the details to complete the picture.

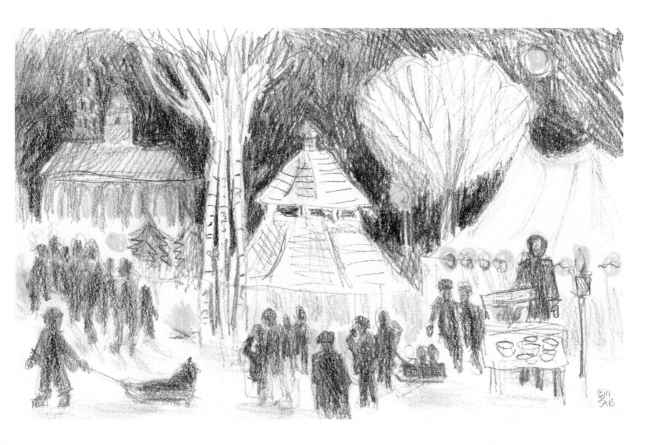

NEW LONDON, NEW HAMPSHIRE

Sure it was cold, being a snowy January night. Winter Carnival weekend with an outside meal on the town common. Local restaurants supply hot steaming food, and volunteers scoop it out. Many bonfires helped to keep us sort of warm enough. I brought paper, pencil, and a small clip-on reading light. The groups of figures made wonderful silhouettes. Colors were added at home.

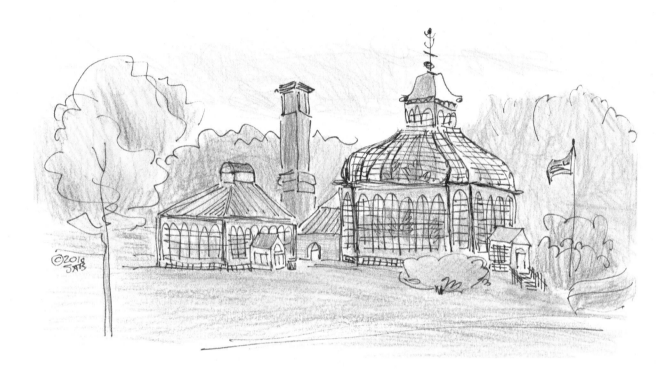

BALTIMORE, MARYLAND

The all glass Rawlings Conservatory near the zoo has a beautiful, graceful shape. I was always attracted to the architecture of it, but unsure whether I could draw it convincingly enough. Unusual things can be tough to draw, but worth a try. A whole series of drawings of all glass buildings would be fun to go out and collect.

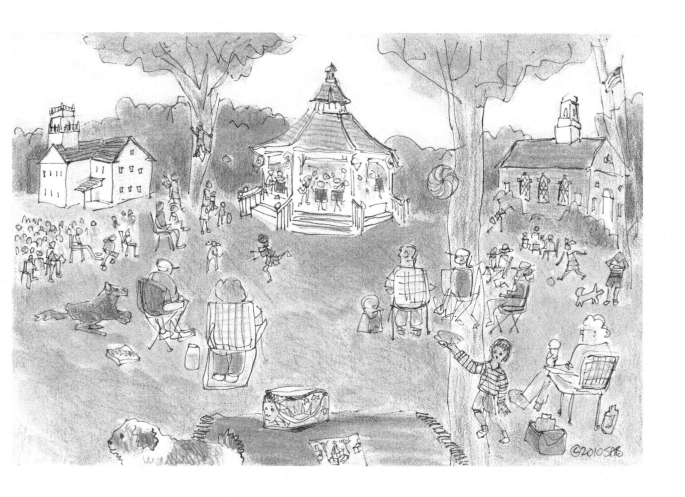

NEW LONDON, NEW HAMPSHIRE

Friday nights in the summer mean band concerts on the town green. People bring chairs, food, and blankets. Kids bring balls, dogs, and inexhaustible energy to run around the large lawn. Three drawing sessions were required to satisfy my urge to get in all the action. I carried the same paper each Friday and kept adding details to it.

MOUNT HOREB, WISCONSIN

My sister is making me some earrings. She has her tools and magnifying lamp over the dining room table. I am capturing a time, a place, and a family connection. The window with its lovely view of a Wisconsin hill-side frames the figure perfectly. Since the drawing is not intended to be an actual portrait, I allowed the light to cover part of her face.

NEW LONDON, NEW HAMPSHIRE

This very quick small drawing means a lot to me. Our daughter was visiting us, bringing with her several work tasks as well as craft projects. She sits near a window in front of her computer screen. Her sewing projects are awaiting her time and attention. Because the iron and the twisted yellow measuring tape are so close to me, their size is distorted and they look huge.

KELOWNA, BRITISH COLUMBIA, CANADA

Cats and little children squirm about, stretch, and walk away. But something about the scene spoke to me, and what it said was 'try'. The cats were much closer to me than my grandson, so they look huge in comparison. I like these kinds of distortions. Squiggy, the grey cat, heard my pencil on the paper and turned to see what was going on.

EDMONTON, ALBERTA, CANADA

Drawing animals is a challenge, even
napping ones. This cat bunkbed sketch
was worth the time involved. The top cat,
Squiggy, is spilling right over the edge of his space. He looks so relaxed.
I had to sway a little to get the face of the bottom cat, Leo, centered in
the circle. Always be aware and thinking of small adjustments to improve
the composition of your drawing.

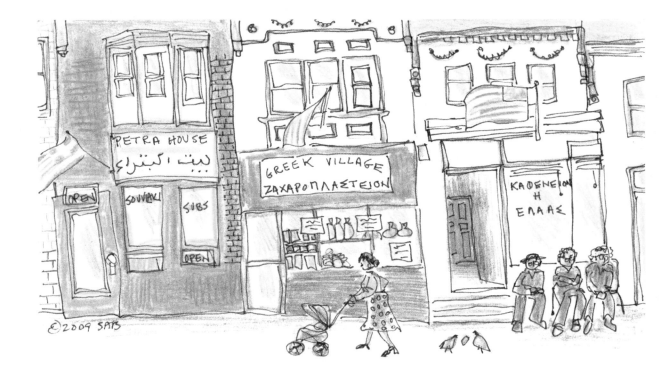

BALTIMORE, MARYLAND

The city has blocks and blocks of brick rowhouses, built between 1880 and 1920. These two rowhouses have been painted white with blue trim to echo the colors of the Greek flag. When I saw this scene in Greektown, down went my bags, and out came my paper and pen. No one noticed me. The people only took a few minutes to draw, but I really took my time copying the storefront signs. The shop behind the woman has really delicious cookies.

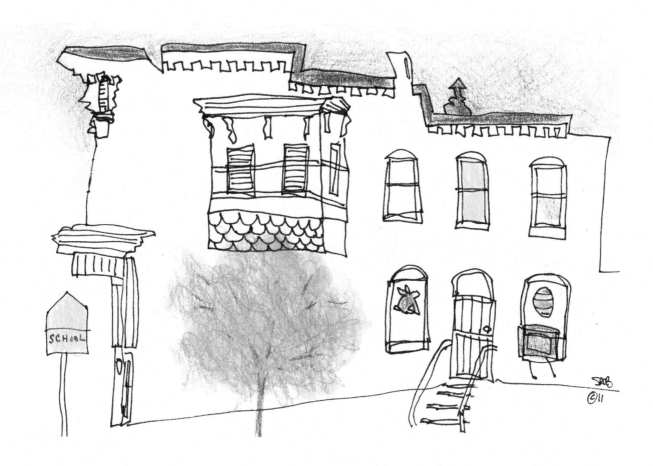

BALTIMORE, MARYLAND

Suddenly, the idea took hold to draw the brick rowhouse and the lovely crabapple tree in full bloom. I grabbed my pen and paper and dug in. The time allotted was five minutes or less as we were all packed and ready to jump into our car and leave the city for the woods of New Hampshire. Rapid ink drawings are some of my favorites. The intensity is there in every line.

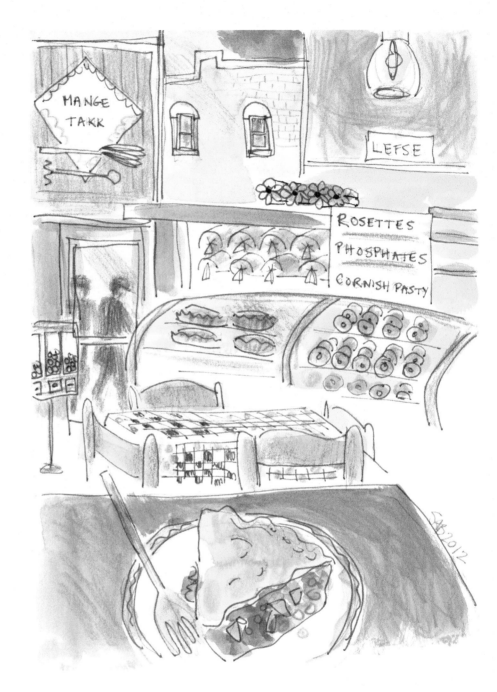

MOUNT HOREB, WISCONSIN

My slice of peach and blueberry pie is front and center stage. I can still taste it. In the background is as much of Shubert's Bakery as could fit in. The table cloth and the food in the case are all patterns that make a strong composition. I invented the two figures to add a sense of depth. The signs are in Norwegian.

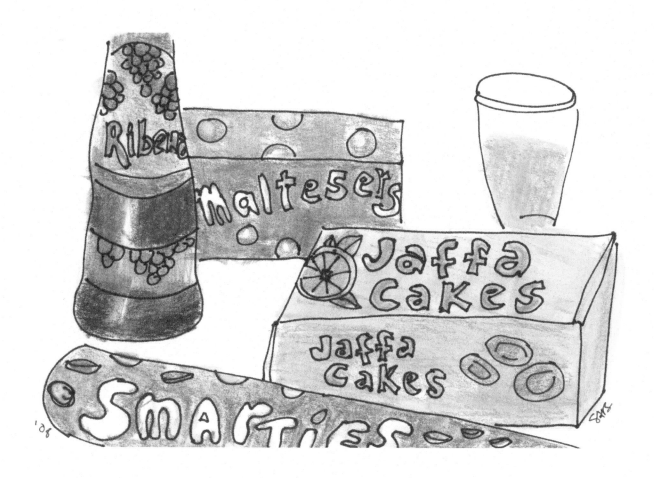

YORK, ENGLAND

Although based in New England, we as a family lived in old England when our children were young. And we were back for a visit. These typical British snacks were bought by me and spread out on the hotel bed. Not the orange drink of course. I made that one up for color and composition. The rest of them had great graphics and made for a quick sketch.

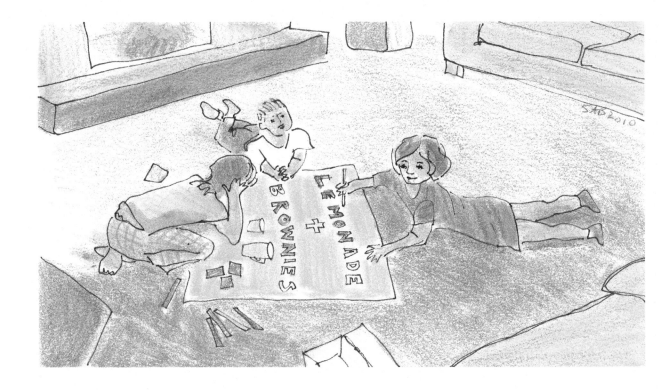

EDMONTON, ALBERTA, CANADA

The day was hot, sunny, and stretched out long on the children's summer vacation. Of course the idea popped into someone's head that a lemonade stand was just what was needed to make a project and a little money maybe. When I saw the three g'kids sprawled on the floor, I quietly grabbed a pencil and paper.

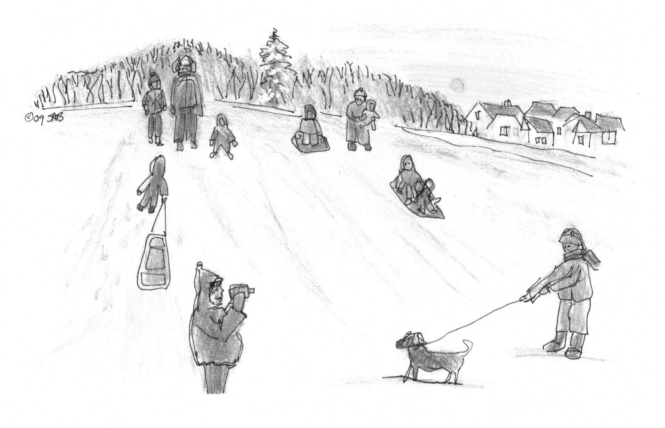

EDMONTON, ALBERTA, CANADA

Our extended family went sledding on a very cold but clear day after the holidays. Tucking a folded envelope and a short pencil into my coat pocket, I felt prepared. The composition and some color notes were all that were necessary. Once back indoors, I redrew it on a larger sheet of paper. To improve the composition and get in all the action, some grandchildren are in the final drawing more than once.

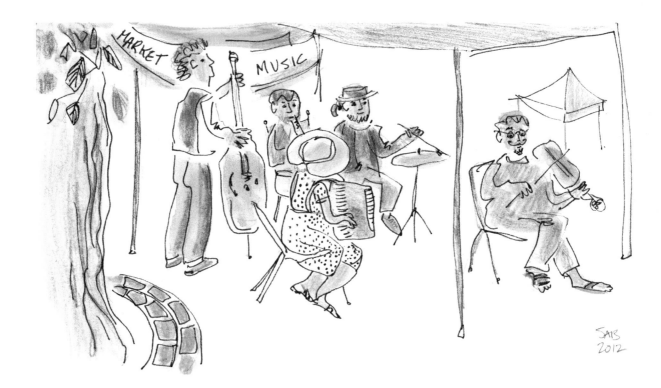

PORTLAND, OREGON

This Klezmer band playing Jewish folk songs was enchanting a large audience at the farmers' market. Combining two art forms like visual arts and music is worth the challenge. They make for a richer and a stronger memory. The woman's lovely straw hat came first, and then her dotted dress. The drawing grew outwards from there. I tried to keep my lines lively to match the tempo.

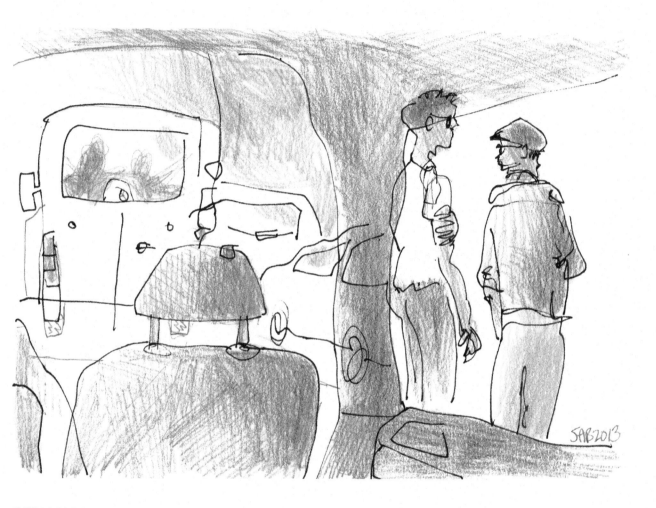

GERMANY

We were stuck in a traffic jam, a *Stau*, in Germany. The awful kind where people start getting out of their cars and walking around. My brother-in-law, on the right, is out on the roadway making a new friend. I was in the back seat engaging in magical thinking. That is, if I start a sketch, the cars will suddenly start moving again. That didn't happen, and I got my sketch completed.

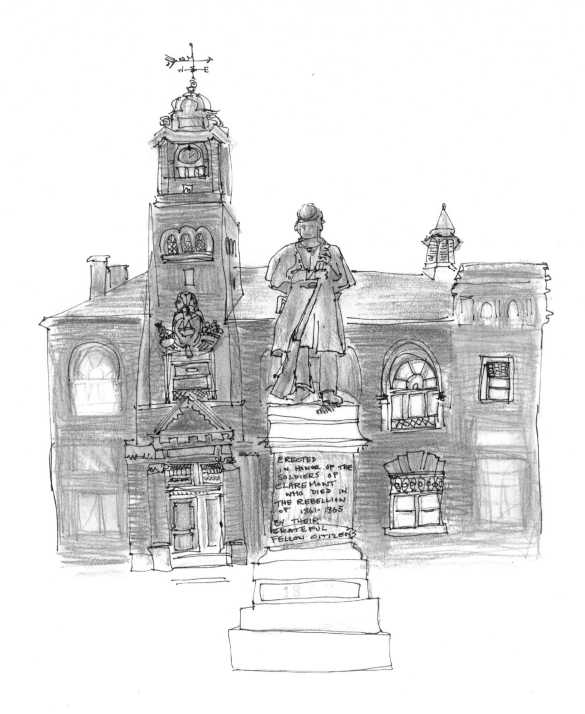

CLAREMONT, NEW HAMPSHIRE

The summer day was warm, hazy, and sticky. The grass was being mowed, and I was asked to move twice. Dry, grassy bits swirled through the air and stuck to my face. But I was there and determined to do justice to this lovely old brick edifice. A row of trees blocks the view from the Civil War Monument to the Opera House, so I drew around them. I am the boss of the composition.

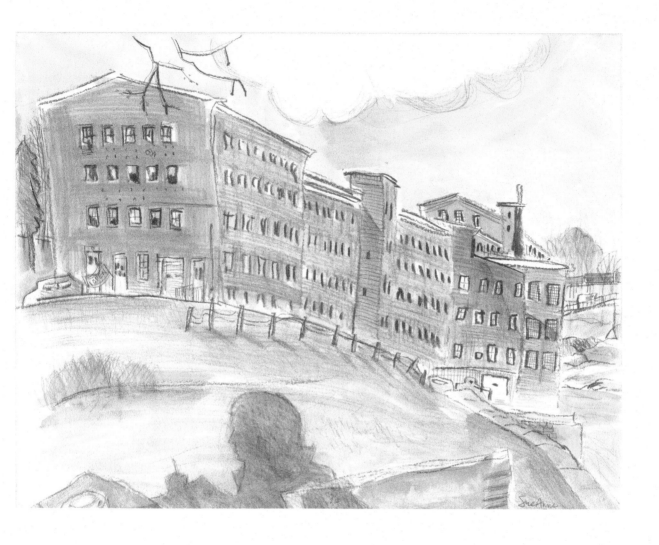

ROLLINSFORD, NEW HAMPSHIRE

The real subject of this drawing is celebration. It was the last town I sketched in my two year project of drawing every town in New Hampshire. Town 234. Most of the long brick building was in deep shadow, but I lightened it to a soft purplish-grey with watercolor. Soft vine charcoal forms the dense blacks of the windows and roofline. Charcoal makes a strong, thick, velvety line.

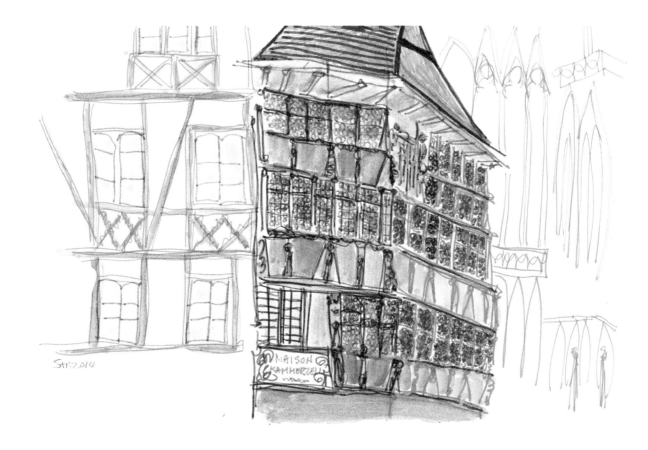

STRASBOURG, FRANCE

I chose to sketch this old house, the Maison Kammerzell, specifically because I felt overwhelmed by its complexity. But the beauty of it drew me in and forced me to try. And the viewer can't tell what is slightly askew, or misaligned. Or even missing. And the great thing is that it doesn't matter. I was going for the general wonder of all those little round green windows placed there in the 1500s.

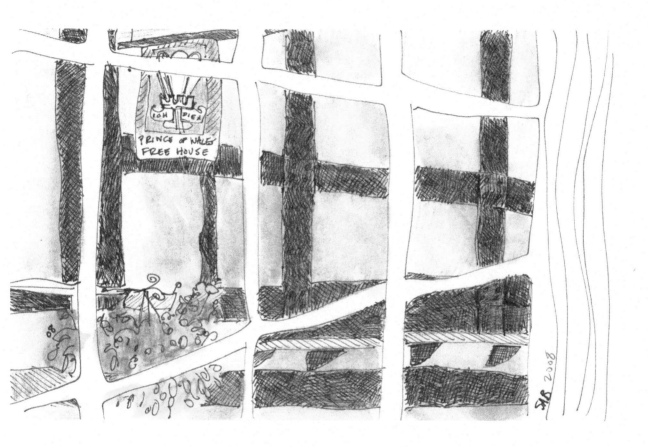

LEDBURY, ENGLAND

Other family members had gone across the very narrow lane to the pub for a musical evening. I was confined to our small sitting room, on the sofa with a cough. The music carried through the night air quite well. I cheered myself up with the challenge of sketching the squares of the half-timbered pub through the leaded glass panes of our cottage window.

EDMONTON, ALBERTA, CANADA

Our granddaughter was almost six
years old at the time. She requested
a drawing of her two favorite dollies.
She held them close and asked that
I draw just the dolls, not her. Without
her noticing, I decided to capture
the entire picture. Of course she is
big now, and her only doll is her new
baby brother.

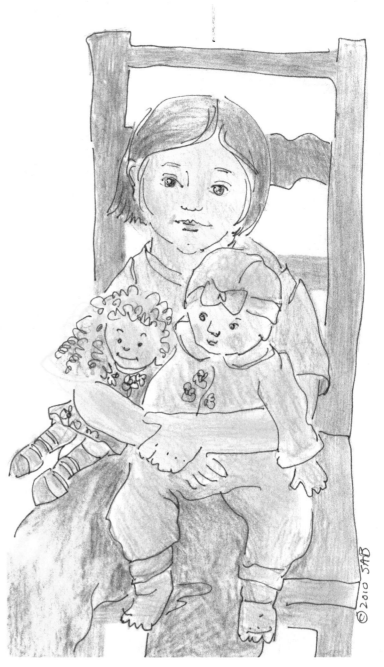

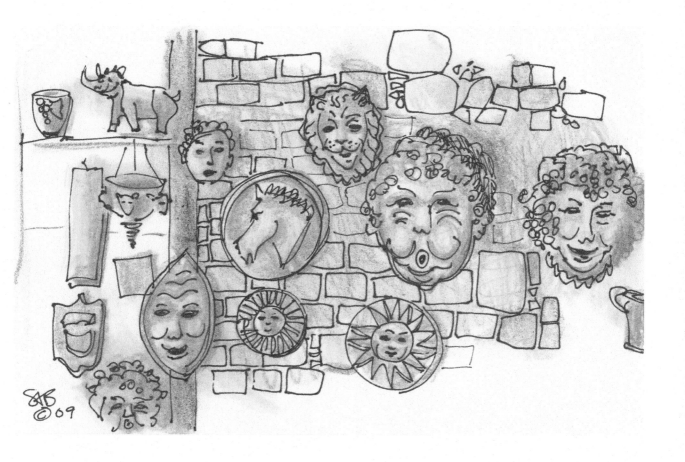

RADDA , ITALY

The sun was warm and the air dry on this day in Tuscany. The display out-
side the ceramics shop caught my eye, so I positioned myself on a stone
wall and sketched the terra cotta garden ornaments. The repetitions of
the shapes in the background stones, plus the many round faces, hold the
composition together. The scene is monochromatic—all one earthy clay
color—so the focus is totally on the molded details.

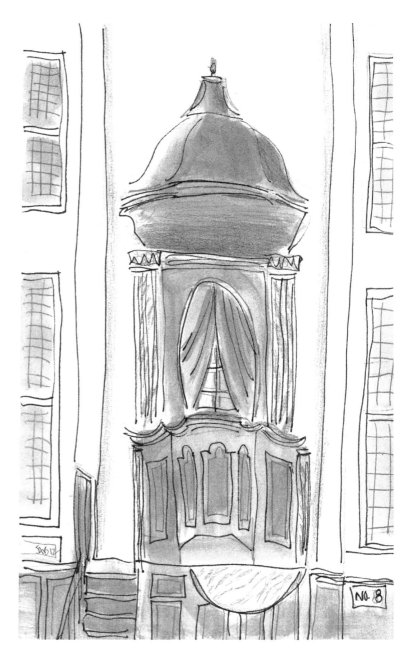

SANDOWN, NEW HAMPSHIRE

I roared into town, planning to
draw the meetinghouse. It seems
that others had plans too. The white wooden structure had been rented at
that same hour for filming. Begging and barging my way in, my drawing of the
old pulpit was complete in under twelve minutes. Urgency can make for an
exciting need to focus the mind and the hand. You really should make an
appointment to have a tour.

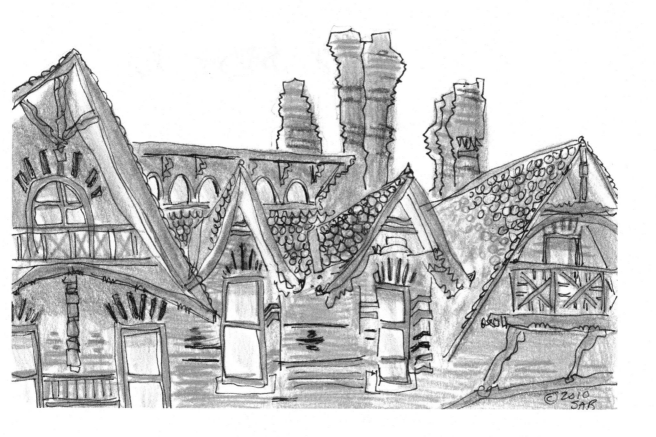

HARTFORD, CONNECTICUT

Large acorns kept dropping off of a nearby, enormous tree and bouncing on my head. It was official acorn drop day at Mark Twain's house. I shifted a little on the lawn and kept going. Architectural elements had to be vastly simplified. The chimneys, the round slate tiles, the red and black bricks were my favorite details, and maybe Twain's as well.

EDMONTON, ALBERTA, CANADA

Our granddaughter was very fond of this summer dress with the flowery pattern. Bright colors and wild shapes on her clothing is her hallmark style. She has sweet rosebud lips. Portraiture is not my strength, but it is well worth a try from time to time to capture a moment in time. Clothing is especially evocative for capturing time, place, and personality.

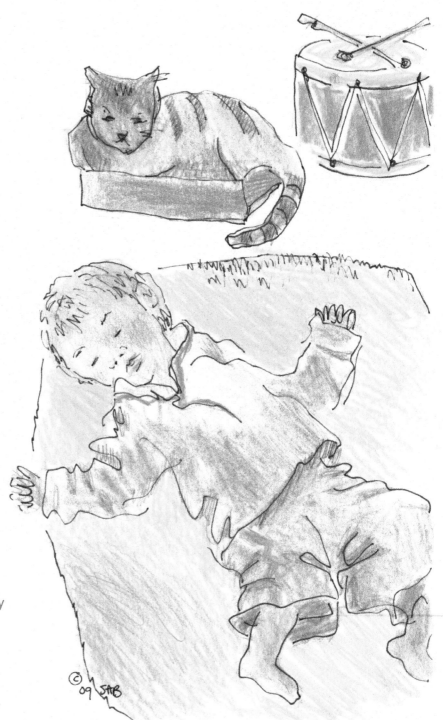

EDMONTON, ALBERTA,
CANADA

Our little grandson is taking
a nap in front of the fire.
A sleeping child makes
a compelling (and still) sub-
ject. The fat cat Peanut looks
comfortable as he looks on.
He overflowed the small box,
but cats do like that cozy feel-
ing. Now years later, the child
is a big boy, he has a new baby
brother, and the cat is gone.

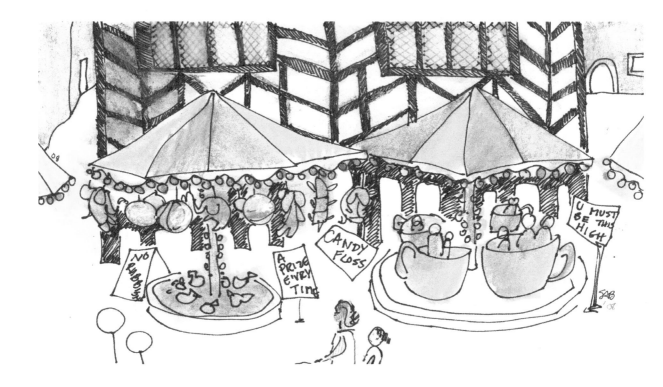

LEDBURY, ENGLAND

Many posters advertised the Hops Fair, so the sketchpad was out and ready. I was first attracted to these two miniature carnival carousels. I loved the small yellow duckies swimming in circles. The parents are meant to be reassured by the sign that says 'no rubbish'. The small peaked tents echo the shapes on the building immediately behind, the raised Market House built in 1617.

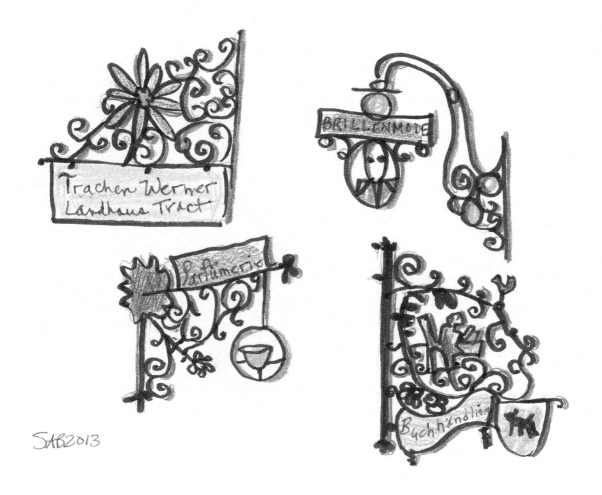

FÜSSEN, GERMANY

These signs captured my attention the entire time while we were having a
very nice meal in a sidewalk café in Bavaria. While still claiming my chair, I
sketched the signs with a marker. Only by drawing them did I really see them
clearly and understand what the ornate ironwork meant. The flower symbolizes
traditional German clothing, then there is eyeglasses, books, and perfume. Yes,
I remember my lunch. Fish.

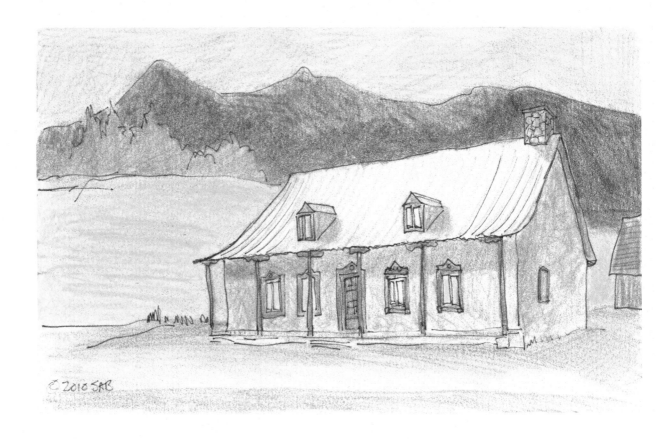

QUEBEC PROVINCE, CANADA

This very house with the typical Québecois sloping roof was the one that
called to me. The only one. It was perfect, except that we had to trespass on
a local's cornfield to get the perfect view. I had to explain what I was doing,
twice, in French, first to one brother, then to another. The brothers each gave
me a thumbs up when I showed them my little drawing of their 'belle maison'.
The mountain did have to be moved to the left, to improve the composition.

It is not all unusual to be invited into a house once you are spotted by the
resident. On-location sketching can be a chance to meet the locals.

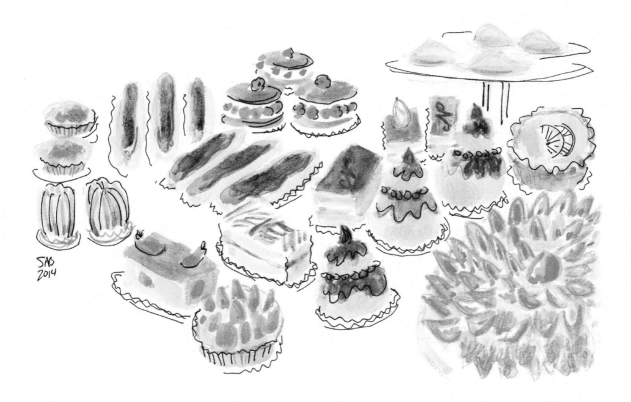

PARIS, FRANCE

The shop window with its tempting, traditional display of pastries was perfect. With my watercolor set and sketchpad in my right hand, and water brush in my left, I set off to capture on paper the lucious pink strawberries, whipped cream, choux puffs, éclairs, chocolate ganache, and lemon curd tarts. One Parisien offered up the encouraging word, 'formidable'.

Tools and Supplies

– Any kind of pencil or pen including ball point pens

– And/or
- Gel pens
- Bic mechanical pencils, always a sharp point
- Pigma Micron pens, various widths
- Faber-Castell Water Colour Pencils
- Koh-I-Noor Woodless Colour Pencils
- Supracolor II Soft Caran d'Ache colored pencils
- Neocolor II Caran D'Ache water soluble wax pencils
- Charcoal sticks and soft vine charcoal

– Any paper, or Strathmore sketchpads, Still & Birn wire sketchbooks, any sketchpad that you will carry faithfully and that fits into your bag or backpack. My standard size for a good fit is about 7" x 10". I also have a small, pocket sized one, and a very long thin one for the occasional panorama. Some people have partially filled sketchpads from many years ago. My advice is to treat yourself to a new one. Also, I carry a few small, cut up pieces of stiff paper in my bag for emergency sketching sessions if I don't have my sketchbook with me.

Start with dry drawing materials. Later you may wish to brush some water onto your water soluble colored pencil drawings to release the pigment. Or you may wish to use some watercolors for color highlights. Thinner paper will buckle with the addition of water, so choose your paper to suit the materials.

If you want to, add a small watercolor set and a couple of brushes. Try the new water brushes with a water reservoir in the handle. Have fun talking to the people in the art supply store about materials and choices.

Check out www.urbansketchers.org for art inspiration and for information on sketching workshops worldwide. Some on-line sketching classes are now interactive.

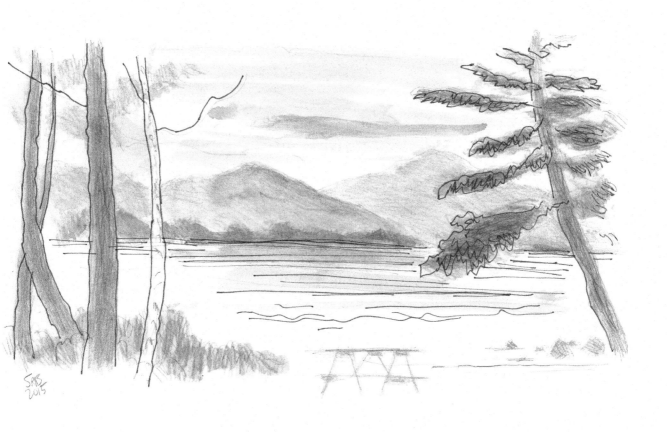

Thanks for coming with me on my sketching journey. Take whatever bits of advice that resonate with you, and set off on an adventure. Draw often, a few times a week. Enjoy the tools, the paper, and the moment!

If you would care to see more of my own sketching explorations, just log on to my monthly arts blog, www.colorfuljourney.us.

CPSIA information can be obtained
at www.ICGtesting.com
Printed in the USA
LVOW06*1319210317
527212LV00010BA/24/P